SAN FRANCISCO
SEALS

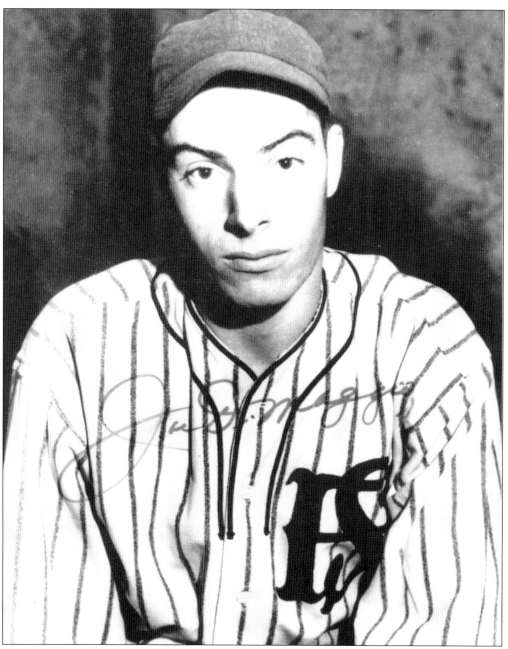

Joe DiMaggio was a legendary Seal. He could do everything—run, throw, hit, field, and he had plenty of guts and hustle. He was an offensive machine and his mind was always ahead of the game. He played four years with the Seals (1932–1935). He will always be remembered for his 61-game hitting streak in 1933. But, during the last day of the season he went 7 for 9 in a doubleheader and finished second in the league with a .398 batting average—only one percentage point behind Mission Red's Oscar Eckhart .399 clip.

ON THE COVER: (top left photo) "Lefty" O'Doul; (bottom photo, from left to right) Vince, Joe, and Dom DiMaggio; (back photo) the 1957 Seals.

SAN FRANCISCO
SEALS

Martin Jacobs and Jack McGuire

Published by Arcadia Publishing
Charleston SC, Chicago IL, Portsmouth NH, San Francisco CA

Printed in the United States of America

Library of Congress Catalog Card Number: 2005920491

For all general information contact Arcadia Publishing at:
Telephone 843-853-2070
Fax 843-853-0044
E-mail sales@arcadiapublishing.com
For customer service and orders:
Toll-Free 1-888-313-2665

Visit us on the Internet at www.arcadiapublishing.com

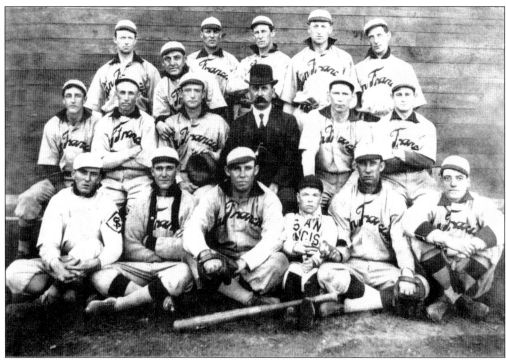

The original 1903 San Francisco team was called the "Stars." The name was officially changed to the "Seals" in 1907. They were managed by Charlie Irwin.

CONTENTS

ACKNOWLEDGMENTS

This book would not have been possible without the assistance of many fine people and resources. I'd first like to thank John Poultney and Arcadia Publishing for giving us the opportunity to make this book project possible.

I'd certainly like to thank my partner and co-author Jack McGuire, who contributed many great photos of the San Francisco Seals and memorabilia to this book. Others who contributed their photos and expertise are Mark Macrae, Doug McWilliams, Carlos Bauer, Art Dikas (former Seals batboy), Nino Cresei, Frank Noonan, and Carl F. Haas.

Many written resources were helpful including Brent P. Kelley's book *The San Francisco Seals, 1946–1957*; Bill O'Neal's *The Pacific Coast League, 1903–1988*; both *Nuggets on the Diamond* and *The Grand Minor League* by Dick Dobbins and Jon Twichell; Donald R. Wells's *The Race For The Governor's Cup*; Fred W. Lange's *History of Baseball—California and Pacific Coast League*; John E. Spalding's *Pacific Coast League Stars Volume No. 1 and No. 2*; Doug McWilliams's *Pacific Coast League News (1946–1951)*; *The Early Coast League Statistical Records, 1903–1957* from Baseball Press Books; San Francisco Seals media guides; my personal library of issues of Seals yearbooks, scorecards, and newsletters; archives of the San Francisco Public Library; the *San Francisco Chronicle*; and the *San Francisco Examiner*.

INTRODUCTION

I started playing baseball when I was six years old with a sock-ball folded up tight and wrapped in duct tape. I used a broomstick for a bat. On weekends, if I wasn't visiting the beach or spending the day at the Saturday matinee watching my favorite superheroes, I was playing stickball in some empty sand-dune lot where I lived in San Francisco.

When I became a teenager, my interest shifted to "Big Rec," a sunken baseball diamond in Golden Gate Park. It was here that promising kids joined the city's best amateurs for an intense game of hardball. Even in the dead of winter these games would draw large crowds—and if I was lucky I might catch a foul ball. Baseball captured my imagination then, and my appetite for it grew even greater as San Francisco Seals pro baseball reined in the city.

San Francisco was part of baseball's Pacific Coast League from 1903 to 1957, but its team didn't officially become known as the "Seals" until the 1907 season. The Seals spawned an enthusiasm that spanned several generations. In six decades in San Francisco, they were the most successful minor-league franchise ever—they finished first 12 times, including 4 Governor's Cups—winning over 100 games a record 24 times.

If I had been around in the first half of the 20th century, I might have called those years the "turbulent times"—an era impacted by the San Francisco earthquake and fire of 1906, the Great War a decade later, the Depression years of the 1930s, World War II in the 1940s, and the Korean War in the early 1950s. But for a local baseball aficionado like myself, that era might also be remembered as the most inspiring years of our lives.

Still, through all this unsettledness the Seals flourished. My dad became a big Seals fan by way of the East Bay. Though he grew up in Oakland in the 1920s watching the Oaks at Emeryville Park, he never missed an Oaks-Seals game. During those formative years, he says, transportation was limited because very few people owned an automobile. It was not uncommon for players to be seen in full uniform traveling on ferries, trolleys, and bicycles with equipment bags slung over their shoulders.

With help from the major leagues, the Seals were provided, to some degree, with star-quality players. Others on the team were past their prime or just finishing out their careers. Homegrown rookies engendered San Francisco's pride. Whenever one of the city's own made it big, fans became both saddened and heartened, because a local star had departed to the big leagues. It wasn't uncommon for teenagers to drop out of school to play for the Seals. Because the competition was so intense for spots on the roster, most teenagers would jump at the chance to play as long as an approving parent signed the deal.

Nevertheless, the city produced outstanding young players. The DiMaggio brothers—Joe, Dom, and Vince—from a crab-fishing family in North Beach, revitalized the Seals in the 1930s. Perhaps the city's all-time favorite Seal and personality was Frank "Lefty" O'Doul. O'Doul's popularity as a player and manager lasted over a span of more than 30 years.

As popular as the DiMaggios and O'Doul were to Seals tradition, other stars contributed greatly to the team's heritage, including Paul Waner, Earl Averill, Willie Kamm, "Lefty" Gomez, Ferris Fain, Hugh Luby, Sam Gibson, Smead Jolley, and Larry Jansen. The list goes on and on. Six former Seals—Joe DiMaggio, Harry Heilmann, Earl Averill, "Lefty" Gomez, and Paul and Lloyd Waner—are enshrined in the distinguished baseball Hall of Fame.

I was too young to have witnessed the early Seals, but as a 13-year-old youth in 1956, I hawked peanuts and ice cream bars at Seals Stadium. I loved that stadium; it was cozy and the fans there were boisterous and passionate. I remember the bright uniforms with "SEALS" lettering emblazoned across their chests just like the big league Red Sox wore. Players like Marty Keough, Albie Pearson, Frank Kellert, Bill Renna, Ken Aspromonte, Hayward Sullivan, and Leo Kiely were my heroes then.

The last year the Seals played in San Francisco was 1957. It was a fitting conclusion to Seals baseball in the city. They won their final pennant—an event that marked the beginning of my life-long romance with the team.

What began on the sandlots of San Francisco almost a century ago now continues on a big-league field called SBC Park where the major league San Francisco Giants play today. Seals Stadium is gone, but the Giants play the same game of baseball that the Seals once did. As a longtime fan, I will never forget the team. In this new book, *San Francisco Seals*, I hope to rekindle fond memories of those legendary Seals—arguably the greatest baseball team in Bay Area history.

—Martin Jacobs

Even though, it cost me a week of detention in grammar school, one of my fondest memories was opening day in 1956—the Seals versus Vancouver. My older brother and his friends decided to leave school at lunch time and took me with them. It was my very first professional baseball game and what a thrill it was. From then on I became hooked on Seals baseball. I visited Seals Stadium frequently, going early and staying late to get autographs. I'll never forget my fond memories of the players: Jerry Casale, a pitcher who hit a 560-foot home run; Manager Eddie Joost blowing up at umpires; Frank Malzone arriving from Boston with a packed car asking me for directions to the clubhouse; Albie Pearson fooling around with the kids like he was one of us; Bill Renna's monstrous home runs, matching Steve Bilko of the Angels for power; Leo Kiely seemingly winning every time he took the mound; and the antics of Joe Gordon and his players during the second game of the doubleheader during their final game at Seals Stadium in 1957. I was happy we won the pennant that year, but I was sad when they left.

—Jack McGuire

ONE

THE FORMATIVE YEARS

During the Pacific Coast League's (PCL) initial season, San Francisco's inaugural game was played on Thursday, March 26, 1903, on the Recreation Grounds at Eighth and Harrison Streets. They defeated the Portland Browns, 7-3, behind the pitching of George Hodson, before 5,500 people. They were managed by Charlie Irwin and the team ended the 1903 season in fourth place with a record of 107-110—29½ games behind Los Angeles. Pitcher Jimmy Whalen pitched in 52 games and posted a 29-21 record and a 2.98 earned run average (ERA) to lead the team. In the early years, the team's name changed frequently. Unofficially they were called the "Stars," until 1907 when the team officially became the "Seals."

The team survived their first year, but it was far from easy to make a profit. In 1904, rosters fluctuated greatly and it was not unusual for a majority of the players to be gone after one year. Ticket prices increased from 25¢ to 35¢. Still, the team slipped to fifth with a 101-117 record. Outfielder and third baseman George Hildebrand (.283) led the team in hitting.

By 1905 the season lasted eight long months, ending in early December. There simply was too much baseball and fans were losing interest. The team, now managed by Parke Wilson, was in the pennant race until the very end. They finished second with a 125-120 record—just a half game behind the champions Los Angeles. Pitcher Roy Hitt (24-14) was outstanding, while James Whalen led the entire league with 30 victories. First baseman Jim Nelson (.286, 11 triples) sparked the team with his 67 stolen bases.

The team stabilized themselves going into the 1906 season, but then disaster struck the city of San Francisco on April 18 at 5:15 a.m. A massive earthquake and fire devastated the city. The Seals ballpark was destroyed. Play was suspended for two weeks and the league's head office had to be moved from San Francisco to Oakland. When it seemed the earthquake was the final blow to the struggling league, owner "Cal" Ewing responded and guaranteed financial stability for his team to cover payroll expenses. Baseball in the city resumed on May 23, but the remaining games would be played at Idora Park in Oakland until a new ballpark could be constructed. By season's end, the team now nicknamed the "Americans," finished the season with a 91-84 record, good enough for fourth place. The 68 stolen bases by second baseman Kid Mohler (.279), as well as outfielder Harry Spencer, led the team. Pitcher Roy Hitt (31-12, 2.03 ERA) was outstanding and posted the most wins.

In 1907, "Cal" Ewing assumed the league presidency and Danny Long became the new manager. The team's name was officially now the "Seals." A new Recreation Park was being constructed in the Mission District at the corner of Fifteenth and Valencia Streets called "Old

Rec." After all the problems in 1906, the Seals opened their new park on April 6 to a standing-room-only crowd of 10,000. Pitcher John Hickey hurled a complete game—a 4-3 victory over Portland in the morning game of a doubleheader. After a long season, the Seals finished in second place—17 games behind Los Angeles. First baseman Nick Williams (.257) led the team, and pitchers Cack Henley (25-16) and Oscar Jones (29-22) each had nine shutouts.

In 1908, not much changed for the Seals. Once again they finished in third place with a 100-104 record. In the interim, future major leaguers helped boost the team. They were catcher Bill Killefer, third baseman Frank "Ping" Bodie, outfielder Charles Catcher, first baseman "Gabby" Street, and shortstop Rollie Zeider—who had a league leading 93 stolen bases. Skilled first baseman Nick Williams (.270) led the team in batting, while second baseman Kid Mohler scored 118 runs. Pitcher Harry Sutor (27-20, 2.13 ERA) achieved 41 complete games.

The Seals won their first pennant in 1909 with the nucleus of a solid, competitive team. Excellent pitching and a superb defense compensated for average hitting. Behind Cack Henley (31-10, 1.61 ERA), Frank Browning (30-16, 2.06 ERA), right fielder Henry Melchior (.298), shortstop Rollie Zeider (.289), and Ping Bodie (10 home runs), the Seals won 132 games and lost 80—finishing 13½ games in front of Portland.

Danny Long's 1910 Seals were much the same team as his champions from the previous year, though the Seals slipped to third place with a 115-106 record—9½ games back of Portland. The season highlights were pitcher "Cack" Henley's 35-19 record and 1.86 ERA; outfielder "Ping" Bodie's 30 home runs; infielder Ossie Vitt's 42 stolen bases; and infielder Hunky Shaw's .281 batting average to lead the PCL.

Danny Long was a longtime resident of Oakland and an outfielder during the 1890s. In 1907, Long was hired by owner Cal Ewing to be secretary and to manage the Seals. His tenure lasted seven years and included the team's first pennant in 1909.

Pictured here is the opening-day game program, March 26, 1903, from Recreation Park at Eighth and Harrison Street. The Seals beat the Portland Browns 7-3 before a crowd of 5,500.

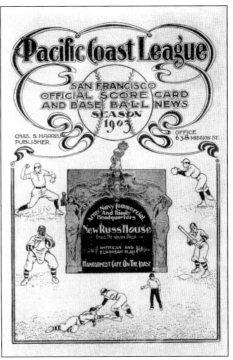

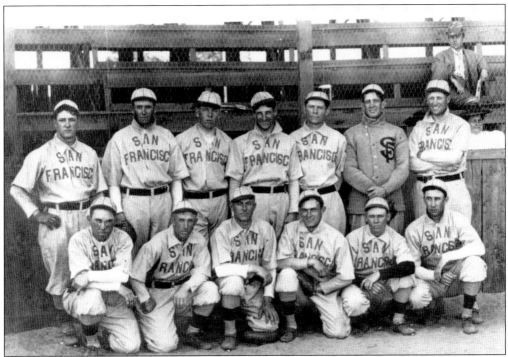

The 1909 Seals, managed by Parke Wilson, finished in second place with a 132-80 record. Pictured here, from left to right, are: (top row) Ping Bodie, Tom Tennant, Roy McArdle, Rollie Zeider, Henry Melchoir, Joe Corbett, and Nick Williams; (bottom row) Jimmy Lewis, Kid Mohler, Claude Berry, Frank Browning, Howard Mundorff, and Cack Henley.

WILLIAMS, SAN FRANCISCO, P. C. L.

Richard "Nick" Williams was one of the Seal's most versatile players (1906–1910). Playing for the University of California at the turn of the century, he formed a unique battery with Earl Overall. While one pitched, the other caught. In the second game of a doubleheader, they would reverse their playing positions. Williams never played in the major leagues, though he had a long career as manager with the Seals (1926–1931).

Ernest "Kid" Mohler was a left-handed second baseman and captain of the 1909 PCL champion Seals. He joined the team in 1905 at age 34 and played eight seasons (1905–1912). In 1896, he broke a team record while pitching for St. Joseph in the brush league—winning 25 straight games before switching positions.

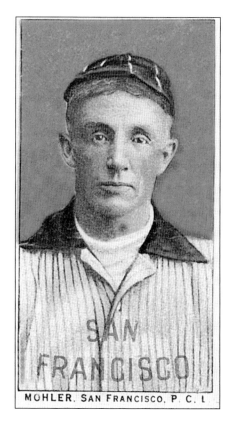

MOHLER, SAN FRANCISCO, P. C. L

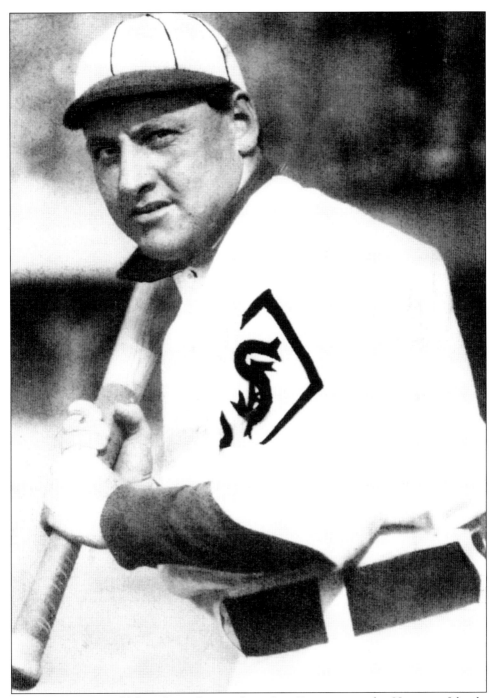

Left fielder George Hildebrand was known from San Francisco to the Hawaiian Islands as "Hildie." He began his career with the San Francisco Athletics in 1898, playing four years in the California League before being signed by Brooklyn. Hildebrand rejoined the Athletics in 1904 and played five more years until 1908. His speed and quickness enabled him to score a combined 627 runs and 286 stolen bases for San Francisco. After retirement, Hildebrand became a distinguished major-league umpire.

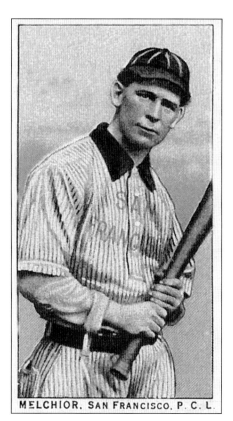

MELCHIOR, SAN FRANCISCO, P. C. L.

Outfielder Henry Melchoir brought experience and speed to the Seals. He had a strong arm and led the league in batting in 1909 with a .298 average. Melchoir played five years with the Seals (1907–1911).

Rollie Zeider played shortstop, third base, and pitcher during his three-year career with the Seals (1907–1909). His quickness was an asset and he was considered one of the best defensive players of the era. Zeider went on to play nine seasons in the major leagues.

Pitcher Clarence "Cack" Henley signed with the Seals in 1905. He had great flexibility and pinpoint control. Everything he threw had movement. On June 8, 1909, he pitched a 1-0, 24-inning shutout against Oakland. He stayed with the club for eight years from 1905 to 1913.

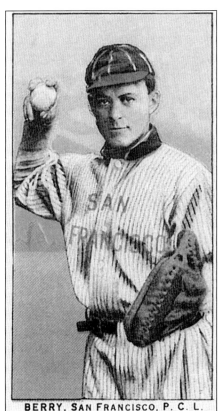

BERRY, SAN FRANCISCO, P. C. L.

Claude Berry was the Seals catcher for five years (1908–1912). He was an excellent defensive catcher and made all the routine plays. Berry played in 731 games during his tenure with the Seals.

Seals power hitter "Ping" Bodie took his last name from the California town of Bodie and his first name from the sound of the ball as it hit his bat. He was a superb outfielder with power and spent seven years with the Seals (1908–1910, 1915–1916, and 1927–1928), hitting a combined 94 home runs.

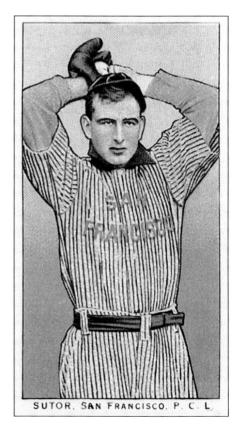

SUTOR. SAN FRANCISCO. P. C. L.

Harry "Rube" Sutor was a great pitcher who was a hurler for the Seals from 1908 to 1912. He could throw fast and had an excellent curveball that would start at your neck and end up at your shoe tops. His control and accuracy was impeccable.

Pitcher Frank Browning was a competitor. He wasn't necessarily fast, but he had a tantalizing curveball. He set a league record of 16 straight wins along with accumulating 10 shutouts and 43 complete games in 432 innings during the 1909 championship season. Browning pitched for the Seals for four seasons from 1908 to 1911.

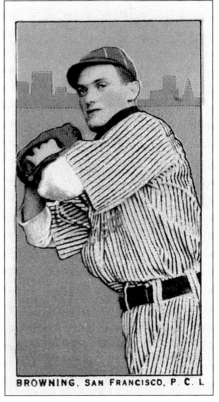

BROWNING, SAN FRANCISCO, P. C. L.

Pictured here is a comical, three- by five-inch postcard of the Seals players—the 1909 PCL champions—with superimposed bodies of frolicking seals.

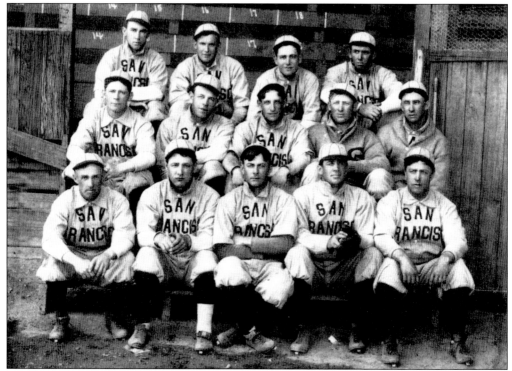

The 1909 PCL champion Seals opening-day lineup was Kid Mohler (2B), Howard Mundorff (3B), Ping Bodie (LF), Tom Tennant (1B), Henry Melchoir (RF), Jimmy Lewis (CF), Claude Berry (C), Roy McArdle (SS), and Frank Browning (P).

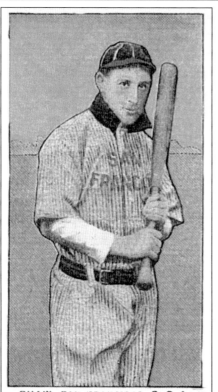

SHAW, SAN FRANCISCO, P. C. L.

Shortstop/third baseman/outfielder Hunky Shaw won the dead-ball era batting title in 1910. He had a great compact swing, always made contact with the ball, and inspired confidence among his teammates. Shaw played two seasons with the Seals (1910–1911).

Oscar Vitt gained a greater reputation as a manager than as a player. Although he played 10 seasons in the American League at four different positions—shortstop, second base, third base, and outfield—Vitt played only 2 seasons with the Seals (1910-11). He was an outstanding performer and could run, hit, and field well.

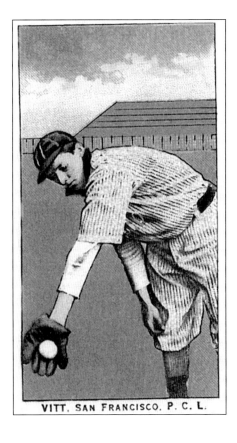

VITT, SAN FRANCISCO. P. C. L.

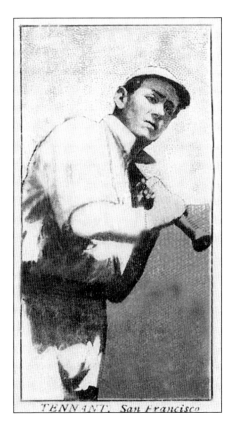

TENNANT. San Francisco

Tom Tennant was a versatile athlete and first baseman. He was talented with good range and a strong arm. Tennant played for three years with the Seals from 1909 to 1911. He started 585 games with a combined .255 batting average and hit 14 home runs.

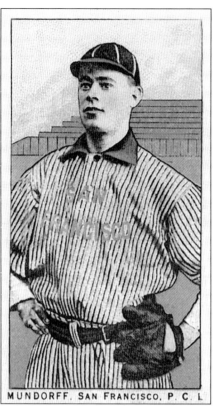

MUNDORFF. SAN FRANCISCO. P. C. L

Howard "Rabbit" Mundorff played three positions—right field, third base, and shortstop—during his six years with the Seals (1909–1914). He had a spectacular throwing arm, and in a game against Oakland in 1912 he threw out four runners at first base while playing right field.

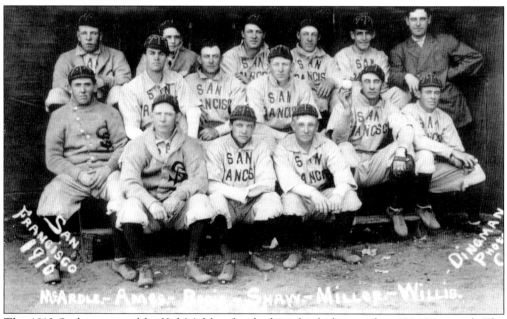

The 1910 Seals, managed by Kid Mohler, finished in third place with a 114-106 record. The opening-day lineup was Hunky Shaw (LF), Roy McArdle (SS), Henry Melchoir (RF), Tom Tennant (1B), Jimmy Lewis (CF), Oscar Vitt (3B), Kid Mohler (2B), Claude Berry (C), and Harry Sutor (P).

TWO

THE TRYING YEARS

The Seals went into 1911 with high expectations, but had a disappointing year. The team finished under .500 and in fifth place with a 95-112 record. Two future major leaguers, second baseman George "Buck" Weaver (.282) and third baseman Oscar Vitt (.269), played exceptionally well. Pitchers Harry Sutor (22-22) and "Cack" Henley (17-14) had the best records.

The Seals were progressively worse in 1912, finishing fifth once again with a 89-115 record. First baseman Del Howard (.358) led the Seals, while fleet-of-foot shortstop Roy Corhan had 32 stolen bases and scored 76 runs. Pitcher Frank Miller (20-22, 2.17 ERA) had the most wins and second-most losses.

In 1913, Del Howard's Seals improved slightly, finishing fourth and reaching .500 with a 104-103 record—11 games back of Portland. Skeeter Fanning topped the pitching staff with a 28-15, 2.45 ERA. Outfielder Jimmy Johnston (.304) led the team and set a PCL record for stolen bases with 124. Owner "Cal" Ewing felt it was time for a change and proposed a move from Recreation Park to a new ballpark. "Old Rec" had served the Seals for seven seasons and Ewing decided to build the new ballpark one block south of Geary Boulevard and Masonic Avenue. The new venue was intended to be the finest minor-league park in the league. Within six months, Ewing Field was constructed.

On May 16, 1914, six weeks into the season, the Seals opened Ewing Field. Moving from "Old Rec" seemed like a huge mistake as fans chose to stay away from the new park due to strong winds, dampness, and ocean fog. Under the leadership of third manager Del Howard, the Seals lasted only part of one season there. They finished in third place with a 115-96 record, just five games behind Portland. Outfielder Justin Fitzgerald's .308 batting average, Biff Schaller's 49 stolen bases, pitcher Spider Baum's 21-12 record and 2.02 ERA, and Skeeter Fanning's 24-18 record were most significant. Because of the financial woes incurred, Ewing then sold the team to Henry Berry, who immediately returned the Seals to Recreation Park for the 1915 season.

A new manager, Harry Wolverton, and two mid-season pitching acquisitions from Detroit, Bill Steen and Tiller "Pug" Cavet, were instrumental in the Seals 1915 pennant drive. First baseman Harry Heilmann got off to a marvelous start, batting .364 in the first 98 games, and the Seals won the pennant by five games over Salt Lake City with a 118-89 record. Pitcher Spider Baum topped the staff with a 30-15 record and 2.45 ERA, followed by Skeeter Fanning's 25-15 record and 2.65 ERA.

In 1916, the Seals managed to finish fourth with a 104-102 record. Outfielder Justin Fitzgerald led the team with a .316 batting average and outfielder Ping Bodie hit 20 home runs. Pitchers Spider Baum (20-19, 2.81 ERA) and Johnny Couch (18-15, 2.68 ERA) led the pitching staff.

The 1917 season was a prosperous one for the Seals as they rebounded to win another pennant under the guidance of Jerry Downs, who replaced Wolverton as the new manager. The Seals finished with a 119-93 record and two games in front of the Angels. Outfielder George Maisel's .308 batting average paced the way. Pitcher Eric Erickson (31-15, 1.93 ERA) had a league-leading 307 strikeouts. The Seals introduced a pitching phenom off the city's sandlots named Francis Joseph O'Doul, who contributed in three games.

After the Seals championship season, they experienced a downslide for the remainder of the decade. With the impact of World War I in 1918 and players being called into the armed forces, the Seals completed only half their schedule. They finished with a 51-51 record and in third place, seven games behind Vernon. Charlie Pick (.324) reigned at third base. Pitcher "Lefty" O'Doul (12-8, 2.76 ERA, 5 shutouts), in his first full season, topped the pitching staff.

Under the new ownership of Charles Strub and Charlie Graham, the 1919 Seals toppled to sixth with a 84-94 record. Outfielder Justin Fitzgerald (.334) and pitcher Tom Seaton (25-16, 2.85 ERA) were the team leaders. Highly regarded third baseman Willie Kamm of San Francisco was signed by the Seals, while shortstop Ike Caveney (.272) made his debut playing in 170 games.

In 1920, the Seals ended the decade by posting a 103-96 record and a fourth-place finish. Outfielders Justin Fitzgerald (.336) and Morrie Shick (.301) outshined others and had an exceptional years. Pitchers Jim Scott (23-14, 2.29 ERA) and Johnny Couch (22-17) also had prominent records.

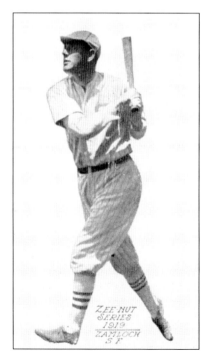

After a 1913 stint with the Detroit Tigers as a pitcher with an ERA of 2.45, Carl Zamloch signed with the Seals in 1919 and played multiple positions: outfielder, second baseman, first baseman, and pitcher, and batted .285 in his only season with the Seals. He became head baseball coach of the University of California, and in 1929 he became a minor partner of the Oakland Oaks and later was named manager.

The talented George "Buck" Weaver
played shortstop, second base, and outfield
for the Seals with great enthusiasm. He
was a sensational utility player and led the
team in batting in 1911. Weaver advanced
to the major leagues for the next nine
years and gained an ignominious place in
history—Weaver was implicated during
the famous Black Sox scandal of 1919.

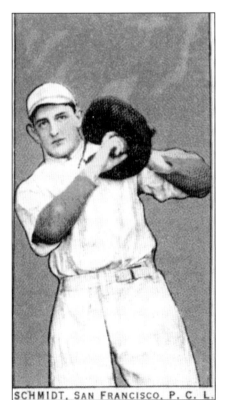

SCHMIDT, SAN FRANCISCO, P. C. L.

After being acquired from the Cardinals
organization in 1911, Walter Schmidt was the
Seals catcher for the next five years (1911–1915).
He was an excellent handler of pitches and hit for
average before moving back to the major leagues. He
managed the Mission Bears in 1926. At age 42, he
played 17 games for the Seals in 1929.

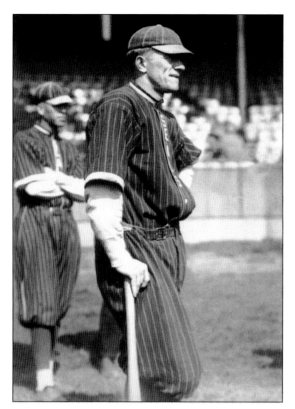

Shortstop Roy Corhan showed great skills and amazing quickness, and his level of intensity was unmatched. He played nine consecutive years with the Seals (1912–1920) in 1,066 games, had 229 stolen bases, and played on two championship teams (1915–1917).

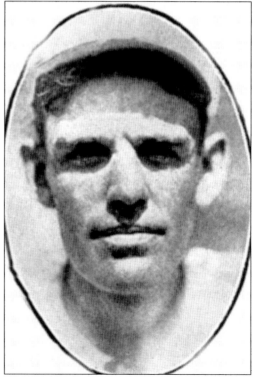

Skeeter Fanning pitched "scientifically." He had great concentration, an excellent curveball and change-up, and knew how to use both. In 1913, Fanning led all hurlers with a 28-15 record. He pitched six seasons with the Seals from 1911 to 1916.

Spider Baum was a highly intelligent pitcher with good balance. He pitched for the Seals (1914–1919) always with a chaw of tobacco in his jaw. Baum was spectacular during the 1915 pennant drive, winning 30 games. He had a combined 114-86 record during those years.

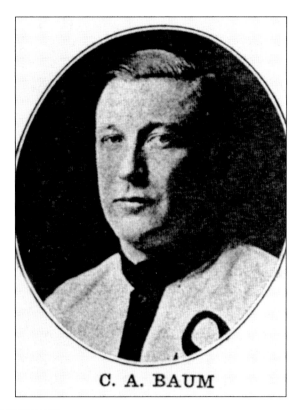

C. A. BAUM

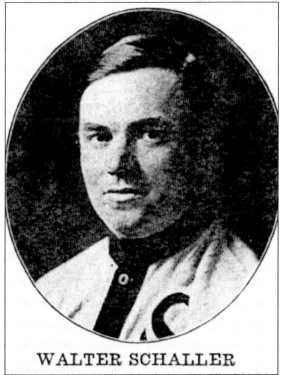

WALTER SCHALLER

Biff Schaller was the Seals slugging left fielder and was labeled as a "dees and dose" type guy. He combined speed with power and played for six seasons (1913–1917 and 1919), appearing in 642 consecutive games with 65 homers (this total includes the two other teams he played for that season). He did not play for San Francisco in 1918, but returned at mid-season in 1919.

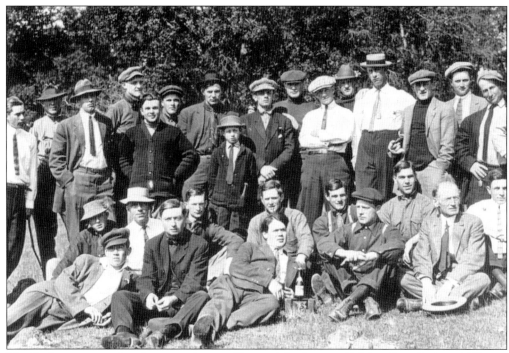

The Seals team spends a day picnicking at Sharon Meadows in Golden Gate Park in 1913.

Pictured is a scorecard from opening day on May 16, 1914, at the Seals new ballpark, Ewing Field, in the Richmond District. Following a parade down Geary Street to Masonic Avenue, 17,844 turned out for the 2-hour and 12-minute game won by Oakland 3-0.

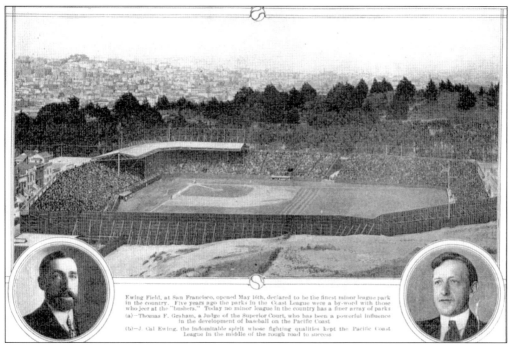

Ewing Field was declared to be the finest park in the league. Supreme Court Judge Thomas Graham (left) and owner Cal Ewing (right) had the indomitable spirit to build the new field. However, it was built in a foggy, windswept section of the city and attendance dwindled. Ultimately, the Seals moved back to Recreation Park for the 1915 season.

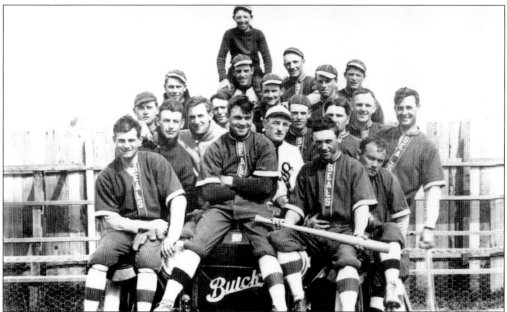

The 1914 Seals, managed by Del Howard, finished in third place with a 115-96 record. The opening-day lineup was Chappie Charles (CF), Charles O'Leary (3B), Biff Schaller (LF), Jerry Downs (2B), Howard Mundorff (RF), Walt Cartwright (1B), Roy Corhan (SS), Walter Schmidt (C), and Skeeter Fanning (P).

First baseman Harry Heilmann, a graduate of Sacred Heart High School in San Francisco, was perhaps one of the greatest players to adorn a Seals uniform. His hitting and fielding talents were aptly suited to the confines of "Old Rec," where he led the team with a .364 batting average in 1915. Though he only played one season for the Seals, he went on to a successful major-league career and into the Hall of Fame.

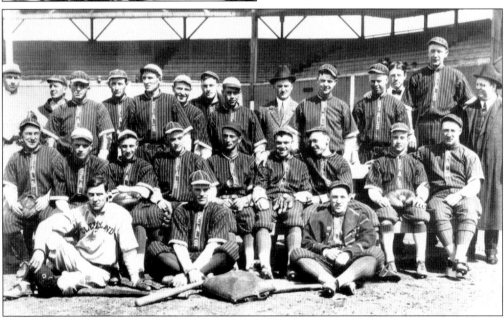

The 1915 PCL champion Seals, managed by Harry Wolverton, finished in first place with a 118-89 record. Pictured here on opening day are team members Justin Fitzgerald (RF), Bobby Jones (3B), Ping Bodie (CF), Biff Schaller (LF), Harry Heilmann (1B), Bill Leard (2B), Roy Corhan (SS), Walter Schmidt (C), and Skeeter Fanning (P).

Left fielder Biff Schaller (left) had 62 stolen bases in 1915, while outfielder Ping Bodie (right) stole 37 the same year. Both players, it seemed, were always on the base paths.

In 1915, the Seals acquired a tall left-hander Tiller "Pug" Cavet. He wasn't overpowering, but he had an excellent fastball. In his only season with the team, he pitched 94 innings with a 5-6 record.

Outfielder Paul "Molly" Meloan powered 11 home runs with the 1915 Seals. He had a world of natural ability, but it didn't come to fruition as a Seal. Meloan lasted one season, playing in 141 games and batting .285.

Outfielder Justin Fitzgerald was a real hustler with incredible speed and always gave the team 110%. He did the little things that great players do over the nine years he played with the Seals (1914–1922).

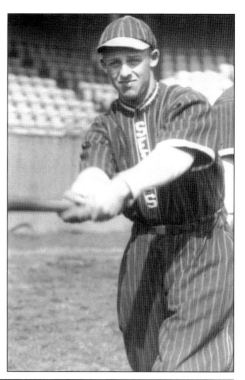

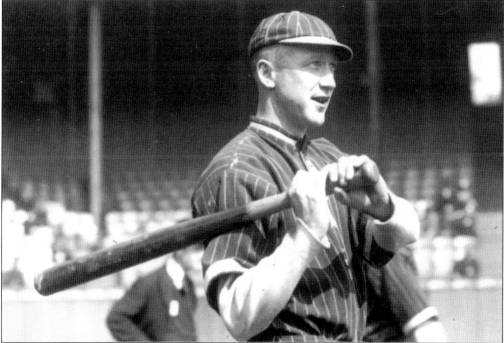

Infielder Jerry Downs was appointed manager by owner Henry Berry in 1917. It was a popular choice with the players as he led the team to their third championship in nine years. In addition, he played in 166 games at second base, scoring 67 runs, 59 RBI, and stealing 28 bases. Downs's career spanned six years with the Seals (1913–1918).

George Maisel (left) was a defensive whiz in the outfield and catcher Del Baker (right) was a free swinger who could hit with power. Maisel batted .308 for the 1917 team and Baker hit .266 in their short tenures with the Seals.

The 1917 PCL champion Seals, managed by Harry Wolverton, finished in first place with a 119-93 record. The opening-day lineup was Justin Fitzgerald (RF), Charlie Pick (3B), Jack Calvo (CF), Biff Schaller (LF), Jerry Downs (2B), Phil Koerner (1B), Roy Corhan (SS), Del Baker (C), and Red Oldham (P).

Third baseman Charlie Pick (left) and manager Harry Wolverton discuss strategy in 1917. Wolverton quit at mid-season and was replaced by Jerry Downs. Third baseman Pick was a fiery player and very agile around the bases. He played two years with the Seals (1917–1918) and had 53 stolen bases in 1918. Pick was known for always having the dirtiest uniform on the team.

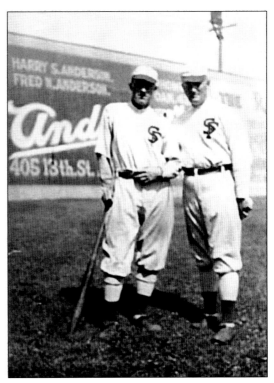

Phil Koerner was the Seals slugging first baseman and played four seasons (1917–1920) with the Seals. He did a workmanlike job with his bat and glove and had a tremendous arm. Koerner played in a combined 561 games and hit in the .275–.300 range.

Eric "Red" Erickson was a pitching sensation for the Seals. He took command of the mound for two seasons in 1916 and 1917. His pinpoint accuracy was uncanny. Erickson had an outstanding 1917 season in which his 1.93 ERA was the lowest in the league.

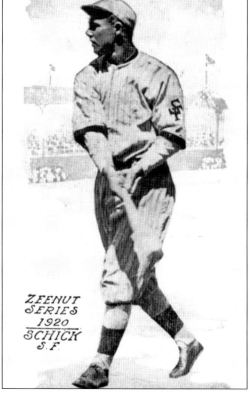

Outfielder Morrie Schick was a quiet leader with a loud bat. He was the sparkplug of the offense in 1920 with his timely clutch hitting. He played three seasons with the Seals (1919–1921).

THREE

RECREATION PARK "OLD REC"

Recreation Park was located a few blocks off Market Street at Valencia and Fifteenth Streets. It was the center of action and home to the Seals from 1907 until 1930, except for the 1914 season when the team made a brief move to Ewing Field. Built in 1907, it replaced the original Recreation Park that the 1906 earthquake demolished. The park, known as "Old Rec," was at the same time beloved and maligned by players and fans alike. It was called a "cracker box" stadium because it was built from warped lumber and hazardous chicken wire. Its structure cracked when the wind came up, but had the warmth fans loved. At first glance, left-handed hitters eagerly eyed the right-field wall, 235 feet from home plate, until they saw on closer examination that it was topped by a 50-foot fence that reduced drives to mere singles. Still, right fielders had to learn the idiosyncrasies of the right-field fence. There were soft spots in the screen where a ball could become wedged high in and the batter could get a "cheap" home run.

The distance to the left-field fence was 311 feet, yet the back wall was low. A strong west wind from the Pacific Ocean held up many fly balls that were destined to go out of the park. Under the grandstand (closed off by chicken wire) was an eight-row section of elevated church pew-type benches known as the "booze cage." This sobriquet was left over from the pre-prohibition days when the 75¢ admission price included either a shot of whiskey, two bottles of beer, or a ham and cheese sandwich. After Prohibition came in, a soft drink was substituted for beer and whiskey. Fans still added bootleg whiskey and gin from their own pocket flasks and portable containers.

The "booze cage" attracted a noisy, hard-drinking, tough-talking crowd made up of teamsters and rowdy fans. They booed, used profanity, and sometimes tussled. Occasional fist fights broke out there. Women were not allowed in the "booze cage."

The clubhouses were located in center field. They were a ramshackle wooden cottage with a peaked roof and two floors for players' dressing rooms. The visitors dressed downstairs, while the Seals players occupied the top floor. The Mission's clubhouse was located behind the third-base dugout. The walk from the pitcher's mound to the clubhouse was a long 325 feet—almost 110 yards.

The park seated 16,500 around the three sides of the small field, with 20 rows of bleacher seats lining the front of the left-field fence. Foul balls caught in the stands had to be returned to the playing field. Still, clusters of children waited with their baseball gloves for the chance to grab a ball coming out of the park. In those informal days, kids with gloves were often allowed onto the field during pre-game batting practice to "shag" fly balls.

Grandstand tickets were $1.25, with a gambling section in the unreserved seats above first base. Usually about 100 bettors would congregate to make wagers on the game action. Though betting was illegal, police never disturbed the action. It was accepted as part of the baseball tradition at the park. Bleacher seats were 50¢ for adults and 10¢ for kids, or you could peek through the knotholes in the fences at no charge. One way or another, fans found a way to see a ballgame at "Old Rec." On weekends, as many as 75 to 100 fans filled the rooftops of the row of houses on Fourteenth Street between Valencia and Guerrero to watch a game.

For 23 years, the aura of the traditional Recreation Park conjured up a number of local heroes—Paul and Lloyd Waner, Harry Heilmann, Ike Caueney, Babe Pinelli, Frank Crosetti, Gus Suhr, "Lefty" O'Doul, Smead Jolley, Ping Bodie, Willie Kamm, and others who gained their fame there.

The great rivalry in the Bay Area was between the Seals and their cross-bay rivals, the Oakland Oaks. There were enormous crowds and the games were intense. Thousands of fans would travel across the Bay by ferryboat to Recreation Park as no bridges crossed from the north and east bay then.

Between 1907 and 1929, the Seals won seven championship pennants while playing at Recreation Park. It became quite common to see a PCL championship flag wavering over the clubhouse on a flagpole during those glory years. In 1929, left-handed first baseman Gus Suhr, aided by the short right-field fence, hit 51 home runs and set a single-season record.

The last game played at Recreation Park was on October 30, 1930. After the World Series ended, an all-star contingent of major leaguers lost to the Seals 17-7 in an exhibition game. The last home run hit at the park was by an ex-Seal Harry Heilmann. Fittingly, it was Heilmann who hit the first recorded home run as a Seal 15 years earlier.

In 1931, the Seals moved to Seals Stadium at Sixteenth Street and Bryant and played there until 1957.

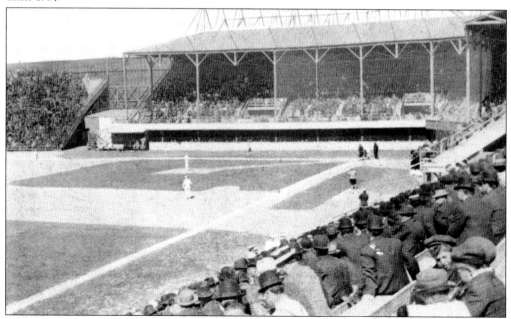

Pictured is Recreation Park, c. 1920.

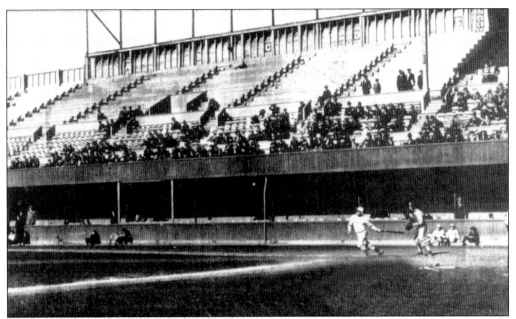

Loyal fans watch the Seals play at "Old Rec" during the 1925 season. The ground level seats, known as the "Booze cage," was where some of San Francisco's staunchest fans congregated. Beer was 5¢ a tub and whiskey 10¢ a belt. It was located behind home plate and extended to both dugouts.

Pictured here is the scorecard from opening day at Recreation Park on April 6, 1920. Mayor James Rolph Jr. threw out the first pitch as Vernon topped the Seals 10-7.

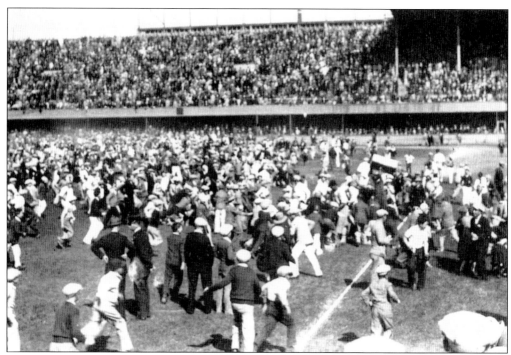

On September 27, 1927, the Seals honored outfielder Lefty O'Doul with a "Kids Day" for his outstanding season. O'Doul, who started the traditional "Kids Day," pitched a two-hit shutout.

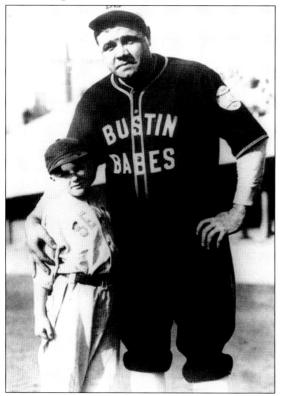

Babe Ruth, representing the "Bustin Babes," poses with the Seals batboy Jack "Whitey" Stuart in 1927 at Recreation Park. Ruth played up and down the West Coast, visiting towns and cities and playing exhibitions against sandlotters.

FOUR

THE FABULOUS 1920S

Although the Seals were one of the top franchises in all of baseball during the 1920s, 1921 was a particularly devastating year for the Seals. They plunged to third place late in the season after leading the league. The Seals opened the season by winning their first 10 games and held a 6½ game lead over the Solons on September 1, but went 12-20 over the last month to finish 106-82—just two games behind Los Angeles. "Lefty" O'Doul led the pitching staff with a 25-9 record and 2.39 ERA, while first baseman Jimmy O'Connell (.337 BA, 101 RBI, 17 home runs) had an outstanding year.

In 1922, under new manager John "Dots" Miller, the Seals won the pennant with a 127-72 record and finished four games in front of Vernon. Third baseman Willie Kamm (.342 BA, 124 RBI, 20 home runs) contributed a healthy amount to the Seals 1,085 runs—an average of five runs per game. Pitchers Jim Scott (25-9, 2.22 ERA) and Ollie Mitchell (24-7, 2.90 ERA) were masterful.

Once again the Seals repeated as Pacific Coast League Champions in 1923. They won the league by 11 games over Sacramento with a 124-77 record. Rookie outfielder Paul Waner (.369) and first baseman Bert Ellison (.358) were the team's batting leaders. Pitcher Harry Courtney (19-6 record, 2.80 ERA) was unrivaled. As a unit, the Seals pitching staff turned in 112 complete games during the 210-game season.

With first baseman Bert Ellison taking over the reigns as manager in 1924, the Seals just missed winning a third straight pennant. They finished in third place with a 108-93 record—just .001 back of Seattle and 1½ games behind the champion Angels. Pitcher Ollie Mitchell (28-15) was spectacular and had the best record in the league. Bert Ellison (.381) and outfielder Gene Valla (.367) were unequaled.

In 1925, the Seals fielded one of their greatest teams ever. They won their third pennant in four years by finishing 12½ games over Salt Lake City and posting a 128-71 record. Outfielders Paul Waner (.401) and first baseman Bert Ellison (.325) were the team leaders. Doug McWeeney (20-5, 2.70 ERA) pitched superior and led the PCL in earned run average. Rookie outfielder Smead Jolley, in just 38 games, batted .447 and hit 12 home runs in his abbreviated season.

In a reversal of fortune, under the leadership of Nick Williams, the Seals plummeted to last place (eighth) in 1926, finishing with 84-116 record. They were 36 games behind the champions from Los Angeles. On the field, the team went sour with poor pitching and mediocre hitting, though rookie outfielder Earl Averill (.348), Smead Jolley (.346), 19-year-old Adolph Camilli (.312), and outfielder Frank Brower (.330) had good campaigns.

The Seals improved in 1927, but only finished second with a 106-90 record—14½ games back of their cross-bay rivals Oakland. "Lefty" O'Doul's .378 batting average, 164 runs, 158 RBI, 33 home runs, and 40 stolen bases led the PCL that year. O'Doul was selected MVP by the sportswriters and was awarded a $1,000 cash prize. Pitcher Buckshot May (20-16) posted the best record on the pitching staff.

For the 1928 season, the league decided to have a split-season format. The winner of the first half would play the winner of the second half and ultimately be crowned the champion. In the first half, the Seals went 58-34, five games ahead of Hollywood. Sacramento won the second half with a 65-37 record. In the playoffs, the Seals beat Sacramento four out of seven games to win the pennant. The Seals finished with a combined 120-71 record and finished eight games ahead of Hollywood. The winning share for each Seal was $9,000. Outfielder Smead Jolley (.404 BA, 143 runs, 188 RBI, 45 home runs) won the prestigious Triple Crown. Hurlers Elmer Jacobs (22-8, 2.57 ERA) and Dutch Ruether (29-7, 3.03 ERA) commanded the most wins and the highest winning percentage (.806).

The Seals finished in second place in 1929 with a 114-87 record, only nine games behind Mission. During the first part of the split season, they finished second, but slipped to fifth in the next half. Nineteen-year-old pitching sensation "Lefty" Gomez (18-11), Elmer Jacobs (21-11), and Sloppy Thurston (22-11) outshined the others. First baseman Gus Suhr (.381) led the league with 196 runs scored while setting a franchise record for home runs with 51.

Though the Seals closed out the decade with a 101-98 record for a fourth place finish in 1930, they had already won four flags—in 1922, 1923, 1925, and 1928. The 1920s were to become the best ever in the history of the franchise. First baseman Earl Sheely (.403) and outfielder Jerry Donovan (.336) had the best years of their careers, and pitcher Jimmy Zinn (26-12) had the best record in the PCL.

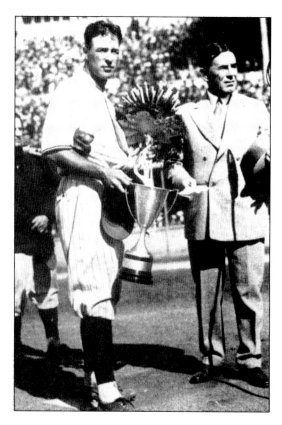

In this 1927 photo, "Lefty" O'Doul receives his MVP trophy from Pacific Coast League President Harry Williams. After his MVP season, O'Doul was drafted by the New York Giants.

Willie Kamm was a superb third baseman and fan favorite. He possessed fair power and played with the Seals for four years (1919–1922) before being sold to the White Sox. On October 15, 1922, fans honored Kamm with a "Willie Kamm Day" and collected $10,019.72 to purchase him a diamond ring. Kamm managed the Mission Reds during the 1936–1937 season.

CALIFORNIA LIVING

THE ALL-STAR DREAM TEAM

Bert Ellison had an abundance of power and could play almost any infield position with great skill. During his seven years with the Seals (1921–1927) he compiled a .335 batting average with 116 home runs. Ellison also managed the Seals from 1923 to 1926.

Sam "Slam" Agnew was a free-wheeling catcher who was quick, smart, and could hit the ball. He played eight seasons with the Seals from 1920 to 1927. His best years were on the Seals' 1922, 1923, and 1925 championship teams. He batted a .325 average, knocked in 167 runs, and hit 44 home runs.

Hal Rhyne was a terrific shortstop. He could field well and had a "snake-like" arm. He could whip the ball from any position. He played ten seasons with the Seals (1922–1925, 1928, and 1934–1938) and seven in the major leagues.

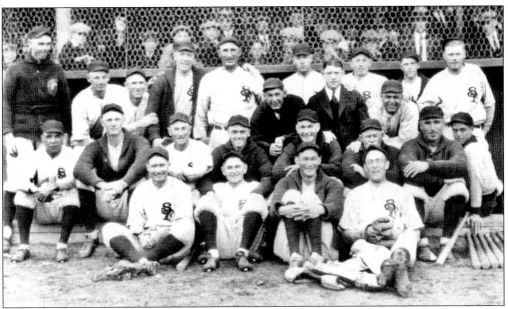

The 1922 PCL champion Seals were managed by "Dots" Miller and finished in first place with a 127-72 record. The opening-day lineup was Charlie See (P), Pete Kiduff (2B), Willie Kamm (3B), Bert Ellison (SS), Jimmy O'Connell (CF), Gene Valla (LF), Ralph Miller (lB), Sam Agnew (C), and Justin Fitzgerald (RF).

Second baseman Pete Kilduff teamed with shortstop Hal Rhyne to produce a slick double-play combination. He knew how to play hitters and make it easy to complete the double play. Kilduff played with the Seals for five years (1922–1926), hitting for average with 487 RBI and 57 home runs.

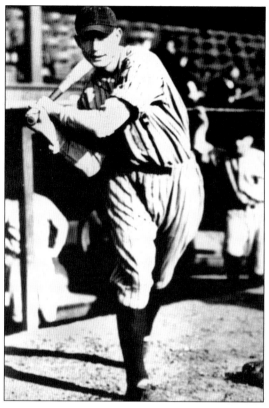

Outfielder Jimmy O'Connell played with the 1922 champion Seals and batted .335. He was a fan favorite. In 1922, a "Jimmy O'Connell Day" was held at Recreation Park and he was honored with a gold and platinum watch for outstanding play that season. His career spanned four years with the Seals (1919–1922). The following year he was sold to the Giants for $75,000. Once a promising player, O'Connell was banned from baseball for allegedly plotting a fixed game.

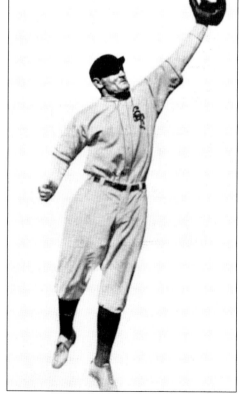

Joe Kelly was a talented outfielder and a superb hitter. He had exceptional speed and was as good a defensive player as there was. During his five years with the Seals (1921–1925) he hit in the .315 range with 257 RBI and 91 stolen bases.

Third baseman Eddie Mulligan had a lot of raw talent and a world of natural ability. He was assigned to the "hot corner" in 1923 and owned that position during his five years (1923–1927) with the Seals. Mulligan played in 886 games and was a great inspiration to the team.

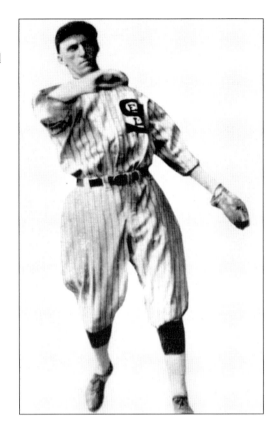

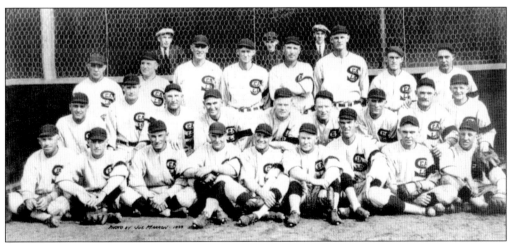

The 1923 PCL champion Seals, managed by "Dots" Miller and Bert Ellison, finished in first place with a 124-77 record. The opening-day lineup was Pete Compton (LF), Gene Valla (CF), Hal Rhyne (SS), Tim Hendryx (RF), Bert Ellison (1B), Pete Kilduff (2B), Eddie Mulligan (3B), Sam Agnew (C), and Harry Courtney (P).

After the Seals faltered late in the 1921 season, they acquired "Dots" Miller, a major-league infielder (1909–1921), to manage the team in 1922. He would lead the team to back-to-back pennants in 1922 and 1923. Miller also sparingly played first base.

Ollie Mitchell was a remarkable southpaw pitcher. At age 27, and a journeyman, he signed with the Seals in 1922. He was the ace of the staff and had excellent control. Mitchell threw where he wanted to. As good a pitcher as he was, he was a decent hitter who hit right-handed. Mitchell pitched seven seasons for the Seals (1922–1928), compiling a 130-75 record.

Big Smead Jolley began his career as a pitcher for the Seals in 1925, but his hitting talents placed him in the outfield. He was phenomenal, batting .447 in 38 games in 1925. Jolley won his first two batting titles—.397 in 1927 and .404 in 1928 for the Seals—and a third batting title in 1938 playing for Hollywood and Oakland. This propelled him to the major leagues for the next four years. He played five years with the Seals from 1925 to 1929.

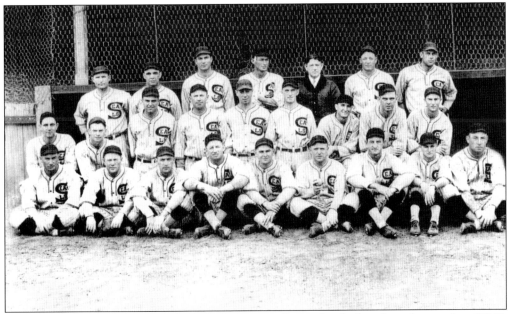

The 1925 PCL champion Seals, managed by Bert Ellison, finished in first place with a 128-71 record. The opening-day lineup was Gene Valla (CF), Ed Mulligan (3B), Paul Waner (LF), Frank Brower (RF), Bert Ellison (1B), Pete Kilduff (2B), Hal Rhyne (SS), Archie Yelle (C), and Doug McWeeney (P).

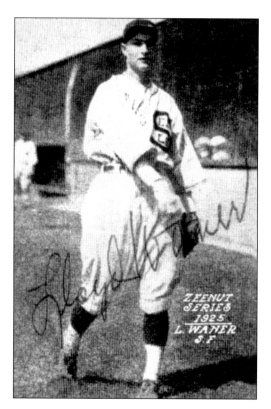

The 5-foot-9-inch Lloyd Waner, nicknamed "Little Poison," was the younger brother of Paul Waner. He broke in with the Seals in 1925 and was somewhat underrated. He had great potential, but in 1926 was released by the Seals after playing in only six games and signed by the Pirates. Lloyd joined his brother Paul in 1927. They were teammates for the next 14 seasons.

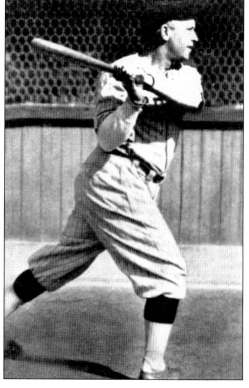

Outfielder Tim Hendryx was an eight-year veteran of the American League who signed with the Seals in 1923. He was a brilliant hitter. He says he never knew what pitch was coming—he just saw the ball and hit it. He could run and field and was one of the few hitters who hit home runs to the opposite field. Hendryx played four years with the Seals (1923–1926). He batted in the .320 range with 243 runs, 201 RBI, and 19 home runs.

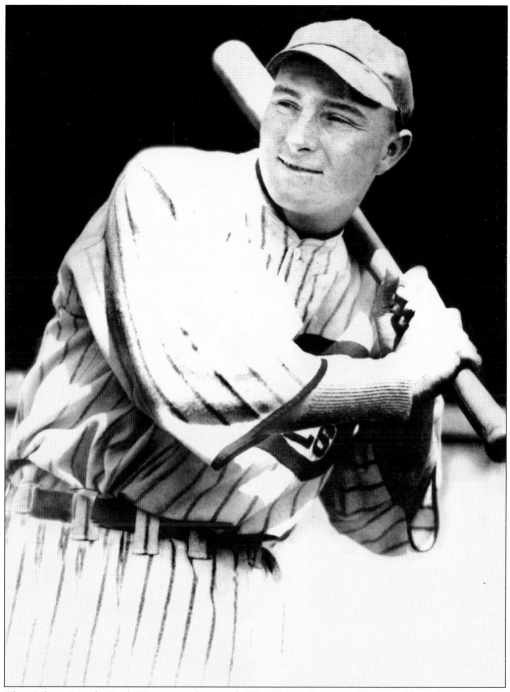

The 5-foot 9-inch Paul Waner, nicknamed "Big Poison," was a 20-year-old rookie when he signed with the Seals in 1923. He was an excellent line-drive hitter, often hitting balls down the foul lines for extra base hits—opening up the power alleys. He sparked the Seals during their championship season of 1925 with a .401 batting average while playing the outfield. Waner played three years with the Seals (1923–1925) before moving up to the major leagues, where he won three National League batting crowns on his way to the Hall of Fame.

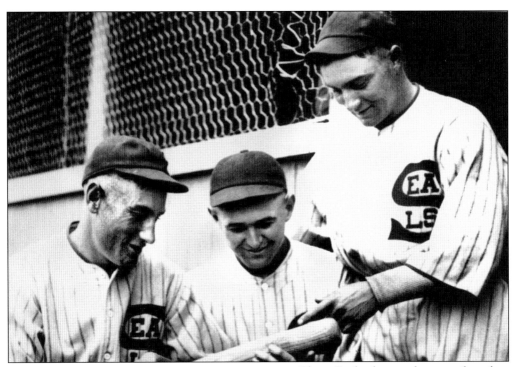

Three Seals players who contributed to the offensive firepower during their championship run in the mid-1920s are pictured here from left to right. First baseman Bert Ellison led the team with 33 home runs and 188 RBI in 1924. Center fielder Gene Valla was the catalyst on the team; he could steal a base and his hitting was impeccable. Valla's five-year reign with the Seals lasted from 1922 to 1926. Left fielder Paul Waner had the team's highest combined batting average (.378) during his three-year tenure with the Seals (1923–1925).

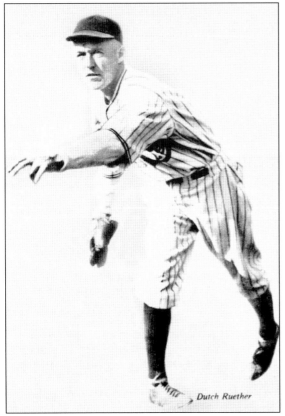

Dutch Ruether

Southpaw Walter "Dutch" Ruether pitched 11 years in the major leagues and anchored the Seals pitching staff in 1928. He won 29 games his only year with the team. Ruether hit so well—.316 in 72 games—that he was frequently used as a pinch hitter.

Earl Averill was a tremendous addition to the Seals in 1926. The future Hall of Famer was an excellent low-ball, fastball hitter. He was part of the Seals triple-threat outfield of Smead Jolley and Roy Johnson. Together they brought the team from a last place finish in 1926 to a league championship in 1928. Averill played three years with the Seals (1926–1928).

Pitcher Walter Mails was nicknamed "Duster" for his frequent brushback pitches. Mails played eight years with the Seals (1924, 1926–1929, and 1934–1936) while compiling a 86-88 record, which includes a stint with Oakland in 1924. In retirement, he served as the Seals official greeter and promoter while enjoying the change to remain in the spotlight.

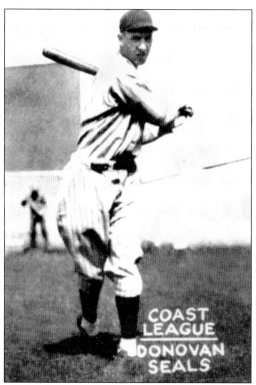

After a slow start, outfielder Jerry Donovan became an outstanding hitter with the Seals. He played with the team for eight years (1926–1933), compiling a career .300 batting average. In 1956, Donovan was appointed president of the club and was responsible for signing several veteran players who aided in the Seals winning their last pennant in 1957.

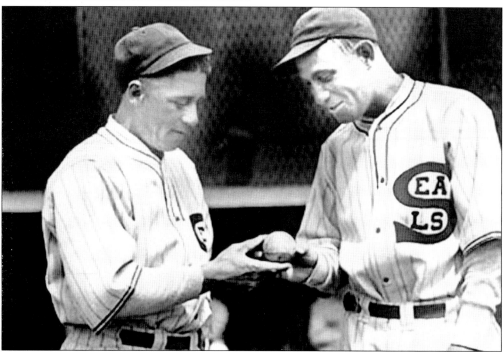

Catchers Frank McCrea (left) and Tony Rego (right) inspect the ball during the 1927 season. Both hit in the .250 range and played for just one season with the Seals. Catcher Joe Sprinz took over the position the following year.

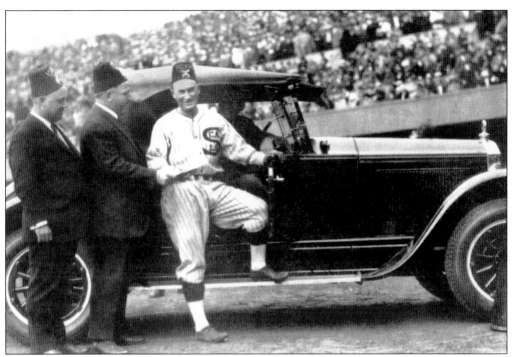

Manager Bert Ellison accepts a new automobile in recognition of guiding the Seals to their third championship of the decade in 1925. The ceremony took place at Recreation Park.

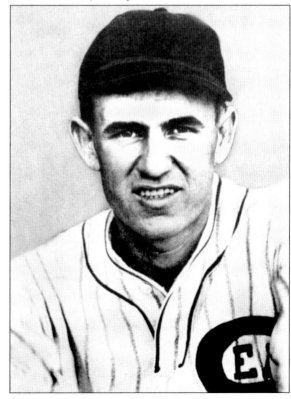

Eighteen-year-old Vernon "Lefty" Gomez pitched only one season for the Seals in 1929 and was outstanding. He had excellent control and accuracy—pitching in 267 innings before being sold to the Yankees. Gomez went on to a Hall of Fame career, posting an overall 189-102 record (1930–1943).

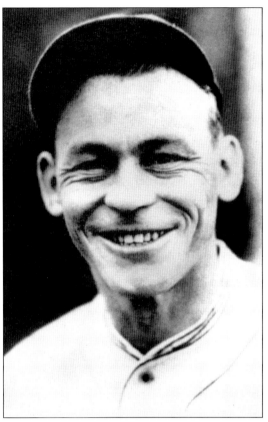

Roy Johnson was a swift, hard-hitting outfielder who landed with the Seals in 1926. In 1928, he was part of the most potent outfield in Seals history (Johnson .360, Smead Jolley .404, Earl Averill .354). Johnson played with the Seals for three years (1926–1928). His 16 triples and 29 stolen bases led the team during the 1928 season.

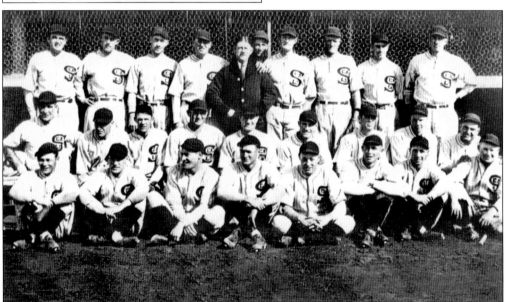

The 1928 PCL champion Seals, managed by Nick Williams, finished in first place with a 120-71 record. The opening-day lineup was Roy Johnson (LF), Frankie Crosetti (3B), Earl Averill (CF), Gus Suhr (2B), Smead Jolley (RF), Solly Mishkin (1B), Hal Rhyne (SS), Joe Sprinz (C), and Jake May (P).

Infielder Babe Pinelli was a heady player and possessed the courage and conviction to be the best at his game. Pinelli was one of the surest-handed third basemen and he hit with power. His biggest game was played on the afternoon of a 4th of July doubleheader. Seattle had a rookie catcher and Pinelli saw all the signs. Ultimately, he went 6 for 6—3 home runs (2 grand slams) and 12 RBI. Ironically, in Pinelli's entire PCL career, he hit only 13 home runs in 4,756 at bats. He averaged .300 during his five years with the Seals (1927–1931). He then logged eight years in the major leagues and later retired to become an umpire in the PCL and the National League. After 22 years of umpiring, his last time as an umpire was Don Larsen's perfect game in 1956.

Pictured, from left to right, are Gus Suhr (1B), Babe Pinelli (3B), Ike Caveney (2B), and Frankie Crosetti (SS)—all part of the fabulous infield during the 1928 championship team.

Frankie Crosetti, 17, signed with the Seals right off the sandlots of San Francisco to play for the team in 1928. He became a superb shortstop and played four years with the club (1928–1931). His .314 batting average from the leadoff spot equaled the entire team's average in 1929 that featured nine batters hitting over .300. Crosetti contributed 151 runs—next to Gus Suhr's 196 and Smead Jolley's 172.

Curt Davis was a tall sinewy pitcher who won a combined 90 games pitching five years for the Seals (1929–1933). He had excellent command of his fastball and curveball, and was the best in the league at picking off runners. Davis advanced to the Phillies and played 13 more years in the major leagues.

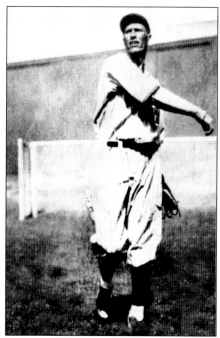

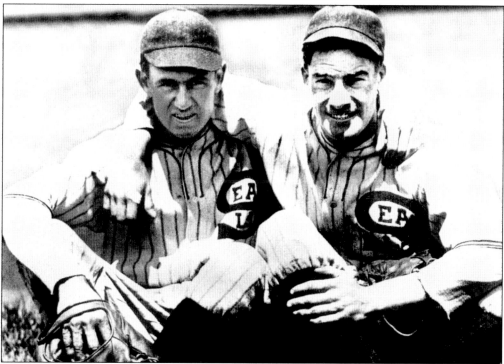

Pictured here are San Francisco's own, pitcher "Lefty" Gomez (left) and Gus Suhr (right). The durable Suhr was a natural hitter during his eight seasons with the Seals (1925–1929, 1943–1945). He hit 51 home runs in 1929, an all-time Seals record. With the team in dire straits to fill their roster in 1943, Suhr came out of retirement to play first base, as many Seals were inducted into the military during World War II.

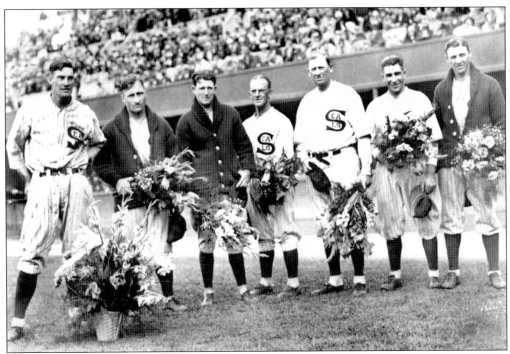

Mission's Merchant Day was held on September 17, 1929, at Recreation Park. The players shown were honored as being raised in the Mission District. Pictured, from left to right, are Gus Suhr (1B), Pop Penebskey (C), Gene McIssac (C), Jimmy O'Connell (C), Manager Nick Williams, Ike Caveney (2B), and Jerry Donovan (OF).

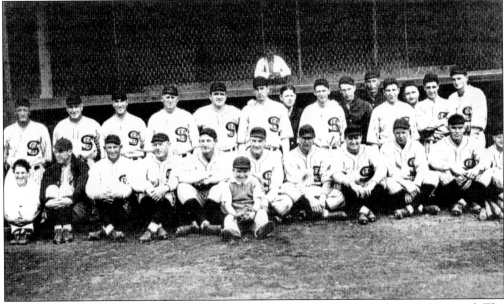

The 1929 Seals, managed by Nick Williams, finished in second place with a 114-87 record. The opening-day lineup was Frankie Crosetti (SS), Babe Pinelli (3B), Sam Langford (CF), Gus Suhr (1B), Smead Jolley (RF), Red Wingo (LF), Ike Caveney (2B), Walter Schmidt (C), and Elmer Jacobs (P).

FIVE

THE DEPRESSION ERA

The new Seals Stadium opened in 1931 with both the Seals and the Mission Reds as tenants. The Seals first game in their new ballpark was on April 7 as Sam Gibson blanked Portland 8-0 before an estimated crowd of 18,000. The Seals won the pennant with a 107-80 record. First baseman Jimmy Keesey (.358), outfielder Prince Oana (.345), and shortstop Frankie Crosetti (.343) were the most consistent hitters, while Sam Gibson (28-12, 2.48ERA) had the best record. Once again, the season was split into halves. Hollywood swept the first half, while the Seals ran away with the second half and won the playoffs. During the off-season, second baseman Jimmy Caveney was promoted to manager.

The Seals finished with a 96-90 record and in fourth place, 13½ games behind Portland, in 1932. Seventeen-year-old Joe DiMaggio was introduced at the end of the season and joined his older brother, Vince, on the roster. Outfielder Ernie Sulik (.313) and second baseman Art Garabaldi (.307) were magnates. Curt Davis (22-16, 2.24 ERA) and Bill Henderson (17-12) were steadfast pitchers.

For the 1933 season, Joe DiMaggio was paid $225 per month. This was an unheard of amount of money for a rookie ballplayer. Joe DiMaggio had an amazing season (.340 BA, 28 home runs, and 169 RBI). From May 28 to July 25, he achieved the record of batting safely in 61 straight games, and in those 237 plate appearances Joe hit 104 times for a .405 batting average. However, it was a shortstop named Augie Galan (.356) who was chosen as the team's MVP. Despite all of this, the Seals slipped to sixth place with an 81-106 record for the year.

The Seals rebounded in 1934 to finish fourth with a 93-95 record. Even though Joe DiMaggio was out much of the season due to torn ligaments in his left knee, he still batted .341 and his 12 homers led the team. Pitchers Leroy Herrmann (27-13) and Sam Gibson (21-17) had admirable seasons.

To promote box-office appeal, owner Charlie Graham brought in "Lefty" O'Doul to manage the Seals for the 1935 season. O'Doul produced another pennant with a 103-70 record and a 5½ game lead in front of Los Angeles. While Los Angeles won the first part of the split season, the Seals rebounded and won the second half by three games. In the playoffs, the Seals won the overall crown, four games to two, from the Angels. Outfielders Joe DiMaggio (.398) and catcher Larry Woodall (.354) dominated opposing pitchers. On the mound, Sam Gibson (22-4) had a banner year with a .846 winning percentage—the highest in the PCL. The Seals also led the league with 178 total stolen bases.

The 1936 season wasn't kind to the Seals. They slipped to seventh with an 83-93 record. With Joe DiMaggio now a Yankee, the veterans had to provide some stability. The dwindling stream

of rookies lacked the punch even though they were entertaining. Veteran outfielders Joe Marty (.359) and Ted Norbert (.313), and rookie outfielder Brooks Holder (.289) played adequately. Pitcher Sam Gibson (18-15, 2.81 ERA, 172 strikeouts) was the workhorse of the pitching staff.

The team rebounded in 1937 to finish 98-80 in second place—four games behind Sacramento. Third baseman Frankie Hawkins (.324) led the team in batting average. Joe DiMaggio's younger brother, outfielder Dom (.306), joined the team and sparked them with his bat. Once again, pitcher Sam Gibson (19-8, 2.84 ERA) was the team leader.

The team remained competitive in 1938, as they moved up to fourth place with a 93-85 record. This qualified them for the Governor's Cup Playoff Series. The league decided that the team finishing first would be the pennant winner. The Seals won four of five games from Seattle in the opening series before faltering and losing to Sacramento in five games during the championship round. Brooks Holder led the team in batting with a .330 average, while Sam Gibson (23-12) continued his dominance during these Depression years.

In 1939, the Seals finished second with a 97-78 record, just 4½ games behind Seattle. Dom DiMaggio (.360) put up big numbers and outfielder Brooks Holder tied a league record with 24 triples. Pitcher Sam Gibson (22-9) continued his remarkable streak.

In 1940, the Seals finished seventh with an 81-97 record. Dom DiMaggio was promoted to the majors and outfielders Ted Norbert (.320) and Johnny Barrett had 40 stolen bases, which provided the offensive highlights for the year. For the decade, the Seals added another two flags during these tumultuous times.

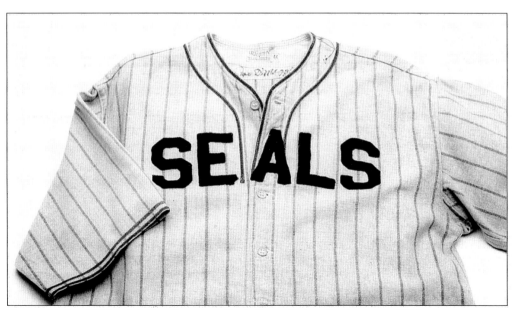

Pictured is Joe DiMaggio's San Francisco Seals flannel pinstripe jersey, c. 1934.

Pictured here is a 10¢ Seals scorecard from opening day on April 7, 1931, at the new Seals Stadium. Ty Cobb came from Georgia to be present at the opener and Mayor Angelo Rossi threw out the first pitch. A sellout crowd of 18,000 watched as the Seals beat Portland 8-0.

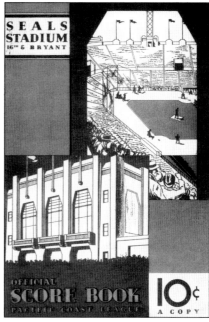

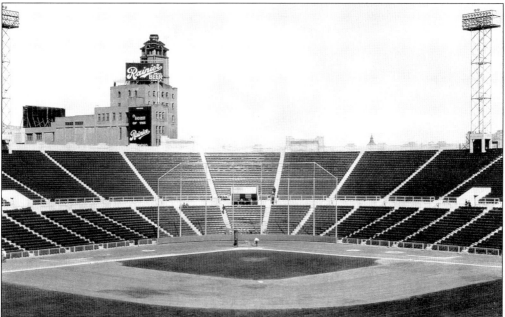

Shown in the photo is an elevated view of Seals Stadium in 1931. The all-concrete stadium sported high-quality lighting and was considered the premier ballpark in the country. Gone were the bullhorns once used to announce the lineups. A state of the art public address system was installed, which was considered advanced technology for the time. During night games, hot soup was dispensed for fans and ladies were admitted free. During World War II, usherettes were introduced for the first time and the old Missions clubhouse became their dressing room. An elevated section was installed down the right-field line for a bandstand. In 1946, the Seals clubhouse on the concourse behind the third-base dugout was equipped with a soda fountain, shoeshine stand, and barber chair.

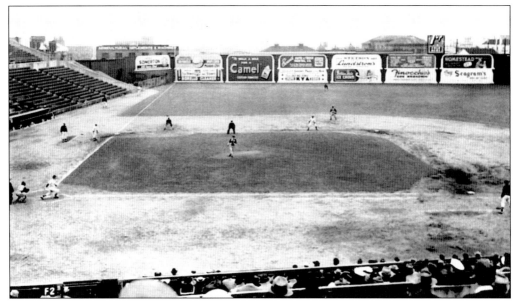

A panoramic view of Seals Stadium shows billboards from places of business such as the famed Finocchio's night club in North Beach. In 1946, billboards were removed on orders from Paul Fagan, who said they were unsightly and the fences were painted green. Signs again appeared in 1954 when the Little Corporation took control of the Seals from Fagan. They needed the revenue.

Pitcher Elmer Jacobs never had a losing season during his four years with the Seals (1928–1931). He was a hard worker and had a good sinker ball. Jacobs was generally among the leaders in strikeouts and ERA, and twice he led the PCL in shutouts (1928–1929).

Jimmy "Ike" Caveney played shortstop, second base, and third base for 10 years with the Seals—from 1919 to 1921 and again from 1928 to 1934. He was graceful and effortless in the field and hit both left- and right-handed pitches well. He also managed the Seals from 1932 to 1934.

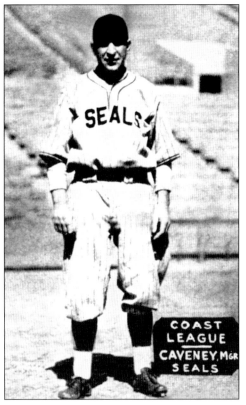

Augie Galan played two years with the Seals (1932 and 1933). He had excellent speed and good instincts. In 1933, he was selected MVP of the team. The popular Galan was then sold to the Cubs for $25,000 and seven veteran players.

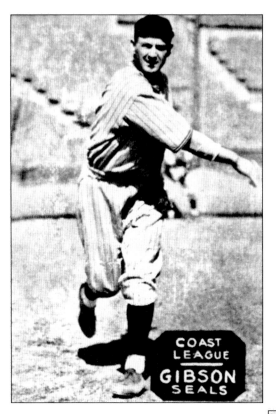

The 6-foot-2-inch Samuel Braxton "Sad Sam" Gibson was the star of the pitching staff for nearly a decade. He was tough and seldom backed down. His baffling sidearm delivery played havoc on batters. Before signing with the Seals in 1934, he pitched in the major leagues for five seasons. During his 12 years with the Seals (1931, 1934–1944), Gibson was a 20-game winner six times. He compiled a 227-140 record.

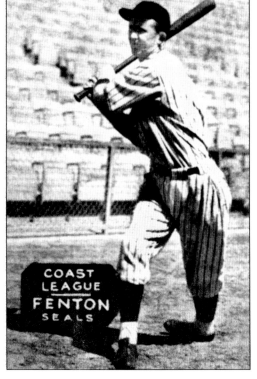

Jack Fenton was a good-hitting first baseman, but was plagued with bad knees. He was a good hit-and-run player—moving players around with solid bunting skills. Playing two seasons for the Seals (1933–1934), he compiled a .306 batting average, 134 runs scored, 145 RBI, and 10 home runs. It was reported that Fenton was traded to the Seals by Memphis for a box of prunes. Fenton was Joe DiMaggio's roommate and advisor for two seasons and was very instrumental in helping DiMaggio overcome some of his shyness.

In his rookie year, Ernie Sulik was considered another Paul Waner, but his statistics declined each year thereafter. Still, he had an infectious personality and was an all-around skilled player in the outfield. The tougher the game, the more plays he made. His tenure lasted five years with the Seals (1930–1934), hitting in the .296 range, scoring 414 runs, 264 RBI, 22 home runs, and stealing 64 bases.

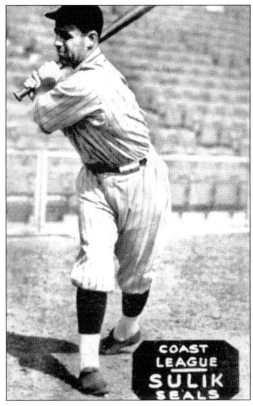

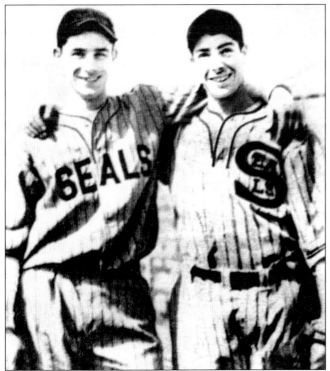

Brothers Joe DiMaggio (right) and Vince DiMaggio played only briefly together. In 1932, Joe played three games at shortstop, while Vince played one game in center field and one game as a pinch hitter. In 1933, they were on the field together in nine games. On May 4, in a game against Hollywood, Joe and Vince hit back-to-back home runs during the fourth inning. After stints with Hollywood and San Diego, Vince was acquired by the Boston Braves and spent the next 10 of 11 years in the majors. He returned to the Seals for the last part of the 1946 season.

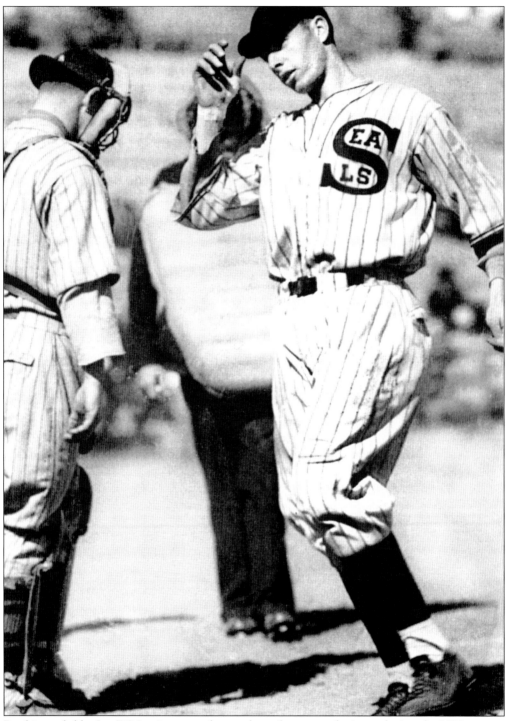
Rookie outfielder Joe DiMaggio crosses home plate after a round-tripper during the 1933 season. That season, DiMaggio hit in 61 straight games—an all-time PCL record.

Joe DiMaggio accepts a gold watch from Mayor Angelo Rossi for setting the all-time, 61-game hitting streak record in 1933. The proud manager, Ike Caveney (center), takes part in the ceremony held at Seals Stadium.

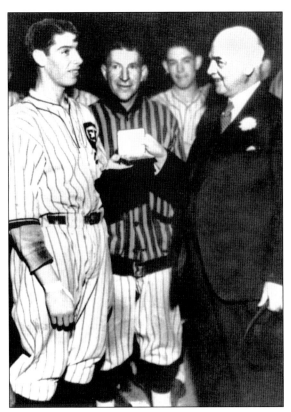

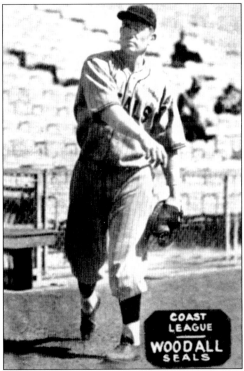

Larry Woodall was an outstanding defensive catcher. He had little power but was an excellent line-drive hitter. He compiled a .295 batting average playing six years with the Seals (1934–1939).

SAN FRANCISCO BASEBALL CLUB, INC.

107 & BRYANT STREETS SEALS' STADIUM PHONE UNDERHILL 3333

SAN FRANCISCO, CALIFORNIA

April 27, 1934

Master Bobbie Baumgartner,
250- Sea View Avenue,
Piedmont, California.

Dear Bobbie:

Enjoyed your letter of April 22nd, which was read over KYA last Tuesday night. Did you hear it?

Regarding the information you request, we will give a baseball school at the Oakland Park on Saturday, May 12. The details will be published soon in the Post-Enquirer.

Note below the signatures of Joe Di Maggio, and Larry Woodall. Sorry Hugh Mc Mullen is in Los Angeles nursing a broken arm.

Sincerely,

Larry Woodall - Catcher
Joe DiMaggio - Outfielder
Hugh McMullen - Catcher
The "Great" Mails - pitcher

A letter of appreciation, written on April 27, 1934, to Seal's players from a devoted fan, was rewarded with the autographs of Larry Woodall, Joe DiMaggio, Hugh McMullen, and Walter Mails.

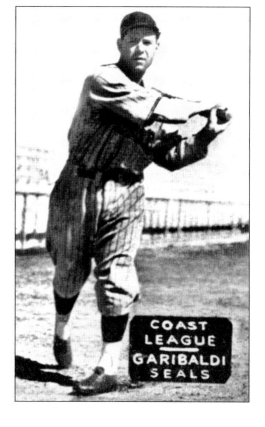

Art Garibaldi was a steady infielder and he would do almost anything to help the team win. He was ferocious with his bat and had exceptional speed. He usually batted leadoff and led the team in stolen bases (1931, 1932, and 1934). During his five years with the Seals (1931–1935), he batted .300, scored 526 runs, had 435 RBI, 141 stolen bases, and hit 24 home runs.

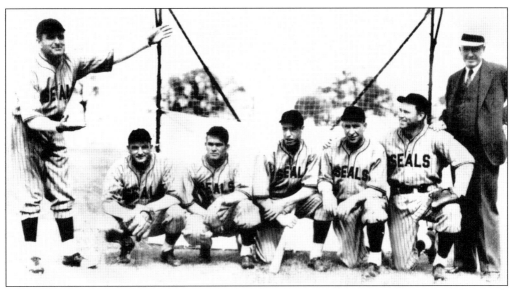

The 1934 Seals take a break during spring training. Pictured, from left to right, are Walter Mails (P), LeRoy Herrmann (P), Larry Woodall (C), Joe DiMaggio (OF), manager Ike Caveney, Jimmy Zinn (P), and owner Charlie Graham.

Seals employees are busy organizing tickets for the season opener at Seals Stadium.

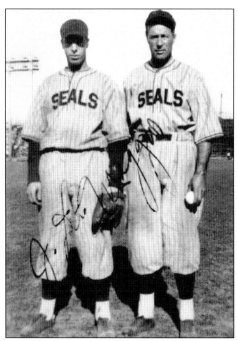

Outfielder Joe DiMaggio (left) and pitcher "Lefty" O'Doul played on the San Francisco sandlots before joining the Seals. DiMaggio credits O'Doul for helping him advance his career to the major leagues, becoming one of the finest hitters in baseball history.

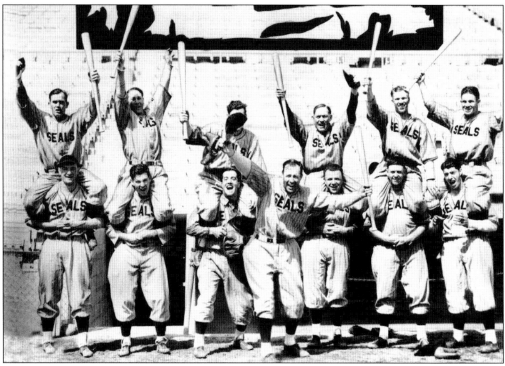

The cheerful 1935 Seals players, with bats raised, appear ready for the season opener against the Mission Reds. Pictured, from left to right, are: (top row) Larry Woodall (C), Lonny Backer (3B), Kenny Sheehan (P), Les Powers (1B), and Art Garabaldi (3B), and Vince Monzo (C); (bottom row) Hal Rhyne (SS), John Thomas (OF), Frank Gira (SS), manager "Lefty" O'Doul, Joe Marty (OF), Brooks Holder (2B), and Joe DiMaggio (OF).

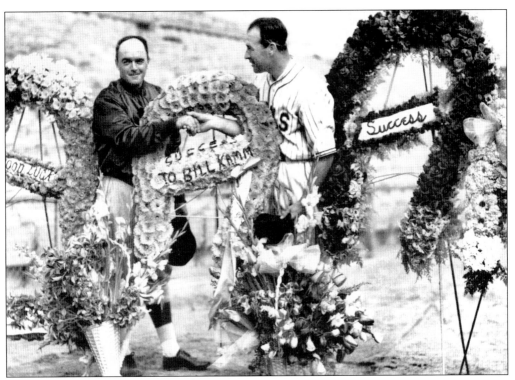

Prior to the season opener on April 18, 1936, Mission Reds manager Willie Kamm (left) is honored for his success. Seals manager "Lefty" O'Doul (right) congratulates him at Seals Stadium. The opener was won by the Reds 11-2.

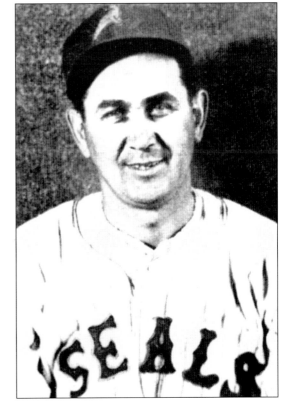

Left fielder Ted Norbert played with the Seals for six seasons (1935–1940). He was a triple threat—hitting 123 home runs, had 681 RBI, 74 stolen bases, and a .304 batting average. He was often called "Pop-Up" Norbert for hitting infield flies with runners in scoring position. Norbert had a weak arm with little range, which prevented him a chance in the majors.

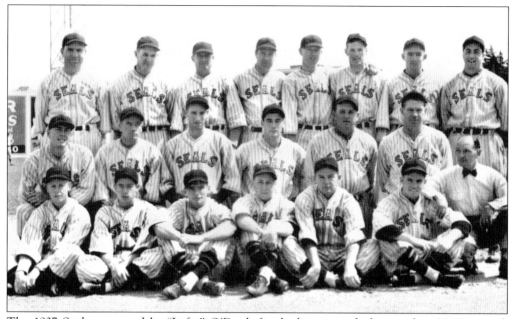

The 1937 Seals, managed by "Lefty" O'Doul, finished in second place with a 98-80 record. The opening-day lineup was Brooks Holder (CF), Hal Rhyne (SS), John Gill (RF), Harley Boss (1B), Ted Norbert (LF), Frankie Hawkins (3B), Al Wright (2B), Larry Woodall (C), and Sam Gibson (P).

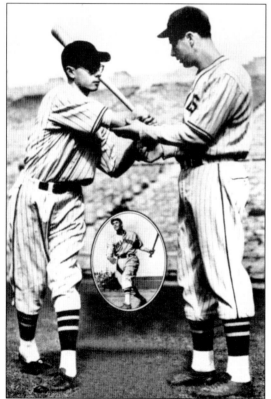

Outfielder Joe DiMaggio (right) helps his younger brother Dom with his batting stance. The composite photo (center) is Vince DiMaggio.

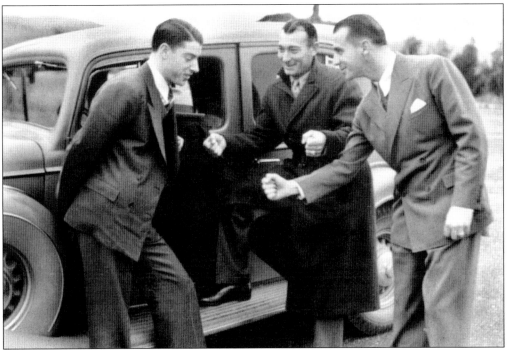

Joe DiMaggio (left) and his Yankee teammates, Tony Lazzeri and Frankie Crosetti, head for spring training in 1936.

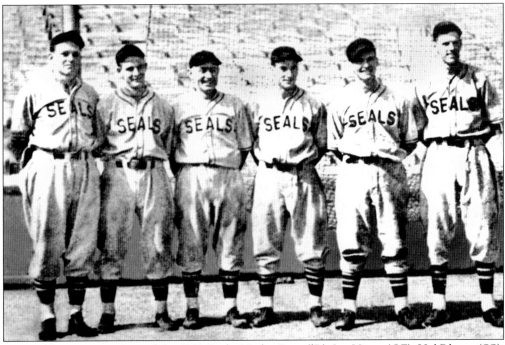

Pictured here are members of the 1937 Seals: Harley Boss (1B), Joe Vitter (OF), Hal Rhyne (SS), Ted Jennings (3B), Frankie Hawkins (3B), and Al Wright (2B).

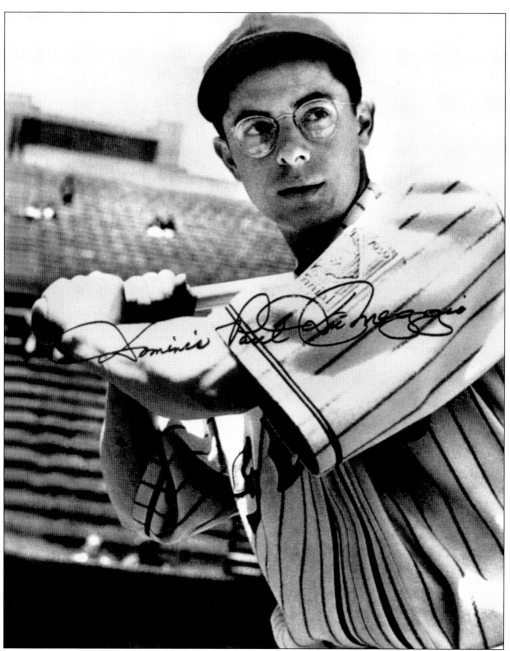

Outfielder Dom DiMaggio, the younger brother of Joe, was called "The Little Professor." When he reported to the Seals he was scrawny and bespectacled, and in those days if you wore glasses you usually did not get a tryout. But with the Depression still on, the Seals were looking for a box-office attraction and the magic name was DiMaggio. "Lefty" O'Doul, a great hitting instructor, spent countless hours with Dom improving his swing. In 1939, during his best season with a batting average near .400, he suffered a wrist injury at mid-season that cut 40 points off his eventual average. He played for three seasons with the Seals (1937–1939). Like his older brother Joe, Dom moved up to the major leagues, playing 10 full seasons in the American League.

Crooning at the piano is "Lefty" O'Doul, along with other Seals players singing the tune "Take Me Out to the Ballgame." This was the final rehearsal for a Shriner luncheon at the Palace Hotel. Pictured, from left to right, are Ernie Raimondi (3B), Keith Frazer (OF-P), Brooks Holder (OF), and Ted Jennings (SS).

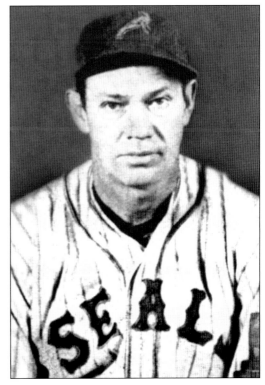

Pard "Win" Ballou was a good 'ole country boy who pitched 10 years for the Seals (1934–1941, 1943–1944). He had his best year with the Seals in 1935 when he was 18-8. At an elder 46 years of age and nearing the end of his career, Ballou became strictly a resident of the bullpen.

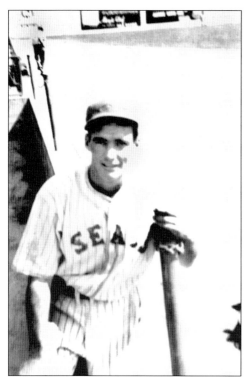

Frankie Hawkins broke into the Seals lineup as a third baseman in 1937 and had excellent power. Sometimes unpredictable and volatile, the fans loved him for his hustle and spirit. He played for three seasons with the Seals (1937–1938, 1942) with a combined .315 batting average and 26 home runs.

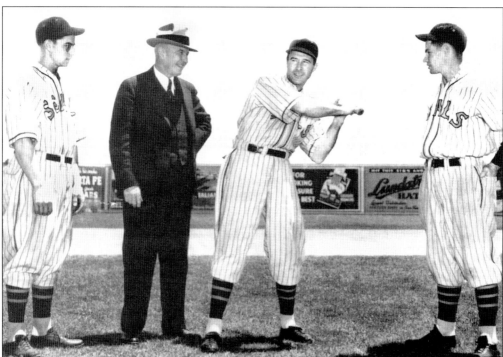

"Lefty" O'Doul was known for his ability to teach baseball skills to his teammates. Here he demonstrates the art of hitting for outfielder Dom DiMaggio (left), owner Charlie Graham, and outfielder Brooks Holder (right) in 1939.

The versatile Brooks Holder built an excellent 17-year PCL career without much fanfare. He signed with the Seals in 1935 and played for 10 productive seasons (1935–1942, 1949–1950). He platooned in the outfield with Dom DiMaggio for the first two months of the 1937 season. Holder flirted around the .300 mark most of his career and his 896 runs scored was a testimony to his amazing speed. He also had 481 RBI, stole 79 bases, and averaged 85 walks.

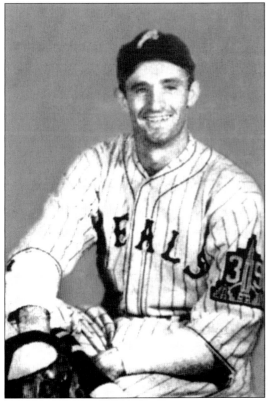

Left-hander Larry Powell signed with the Seals in 1938. He had good command of his pitches and threw an excellent change-up. He appeared in 54 games with a combined 24-18 record during the 1938–1940 seasons. After serving in the military (1942–1945), he played again briefly with the Seals for two years in 1946 and 1947. Powell was another casualty of World War II, missing four instrumental years in his development.

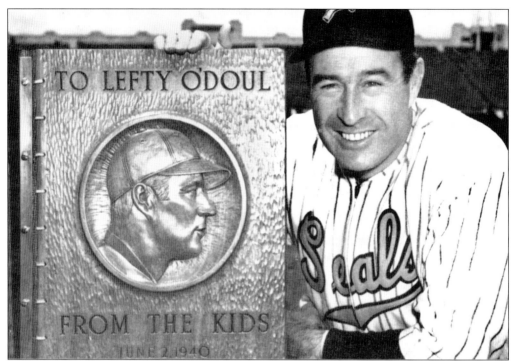

On June 2, 1940, one of the several "Lefty" O'Doul Days held at Seals Stadium, O'Doul is presented a keepsake scrapbook that was signed by hundreds of fans.

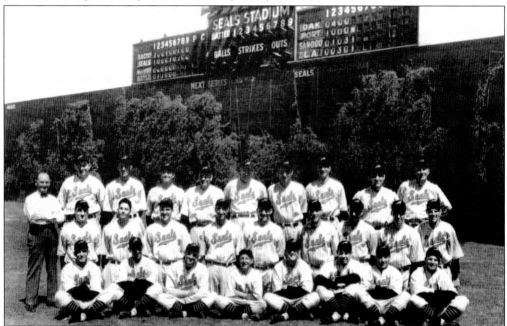

The 1940 Seals, managed by "Lefty" O'Doul, finished in seventh place with a 81-97 record. The opening-day lineup was Johnny Barrett (CF), Ted Jennings (3B), Brooks Holder (RF), Ted Norbert (LF), Harvey Storey (3B), Jack Burns (1B), Al Wright (2B), Joe Sprinz (C), and Orville Jorgens (P).

Six

THE WAR YEARS AND BEYOND

When the Seals opened up spring training at Boyes Hot Springs in 1941, "Lefty" O'Doul signed a crop of young pitchers. Among them were Larry Jansen, Bob Jensen, Hub Kittle, Roy Parmalee, Charlie Shantz, and infielder Tony Lazzeri (as a free agent). The Seals managed to finish fifth with an 81-95 record. Shortstop "Nanny" Hernandez (.327) played every game at shortstop and led the team in hitting. In December, after the attack on Pearl Harbor, a dozen Seals enlisted or were inducted into the armed forces.

In 1942, fan favorite Don White joined the Navy after playing in only 13 games in April. Pitchers Larry Jansen and Tom Seats worked in some defensive capacity and pitched on weekends. The Seals were competitive, but were never in the pennant race. They finished fifth with a mediocre 88-90 record. Bob Joyce (22-10) and Sam Gibson (20-12) were two of the few bright spots on the pitching staff.

By 1943, the war hit baseball really hard. The season was cut from 178 games to 155 and the Seals roster became even smaller. The team managed to finish second in the league with a record of 89-66 and made the playoffs. The Seals went on to win the Governor's Cup as they beat Portland and swept four of six games from Seattle to clinch the win.

It appeared 1944 was a rerun of 1943. Los Angeles once again won the pennant and the Seals won the Governor's Cup for the second year. During the season, the Seals finished tied for third with Oakland with an 86-83 record. In the playoffs, they beat Oakland in five games of the opening round then won four of six from Los Angeles. During the season, pitcher Tom Seats (25-13, 2.36 ERA) led the entire league with 34 complete games.

The last wartime season was in 1945.The Seals finished in fourth place with a 96-87 record —a half game behind the third-place Solons. First baseman Gus Suhr (.311) and outfielder Neil Sheridan (.290) supplied the offense. Pitcher Bob Joyce had a 31-11 record, 2.17 ERA, 100 strikeouts, 35 complete games, and 7 shutouts to lead the PCL. The Seals won the Governor's Cup for the third straight year. In the first round of the playoffs, the Seals prevailed over Sacramento—winning four of six games from them. In the finals, the Seals were challenged by Seattle, but still won the Cup in six games. Joyce continued his dominance during the playoffs by winning four more games.

In 1946, the Seals won their first pennant in 11 years and their fourth straight Governor's Cup. The Seals finished strong to win the pennant. They had 115 victories and 68 losses and finished 4 games ahead of the Oaks. The Seals set an all-time minor-league attendance record with 670,563. Pitcher Larry Jansen (30-6, 1.57 ERA) had a marvelous season and the Seals swept the playoffs, winning four straight from Hollywood and four of six from Oakland.

The Seals ended up tied for first with Los Angeles in 1947 with a 105-81 record. For the first time in their 45-year history, a tiebreaker playoff game was implemented. The Angels shut out the Seals 5-0 and ended their pennant hopes. Bob Chesnes (22-8, 2.32 ERA) had the best pitching record and second baseman Hugh Luby scored 122 runs—also tops on the team. In the playoffs, Oakland eliminated the Seals, taking four of five games in the first round of the Governor's Cup.

Tragedy befell the Seals on August 29, 1948, when owner Charlie Graham passed away. Still, the Seals were competitive and finished second, only two games back of Oakland, with a 112-76 record. Left-handed-hitting Gene Woodling led the PCL with a .385 batting average despite suffering a broken leg during the season. Stellar pitcher Con Demsey (16-11) led the league with 171 strikeouts. As a team, the Seals batted only .193 in the playoffs and dropped four of five games to fourth place Seattle.

In 1949, signs of the days of prosperity were ending as the Seal roster was filled with mainly rookies. They finished a dismal season in seventh place, 25 games behind Hollywood, with an 84-103 record. For the first time since 1942, the Seals failed to finish in the first division and missed the Governor's Cup playoffs.

It was apparent that Paul Fagan was going to have to spend more money to get some offense if the Seals were to be a threat in 1950. They managed to finish .500 with a 100-100 record—18 games behind pennant-winners Oakland. Outfielder Dino Restelli (.341) and first baseman Les Fleming led the team with 126 walks.

Pictured here is the game ticket to the opening series against the Japanese all-stars in 1949.

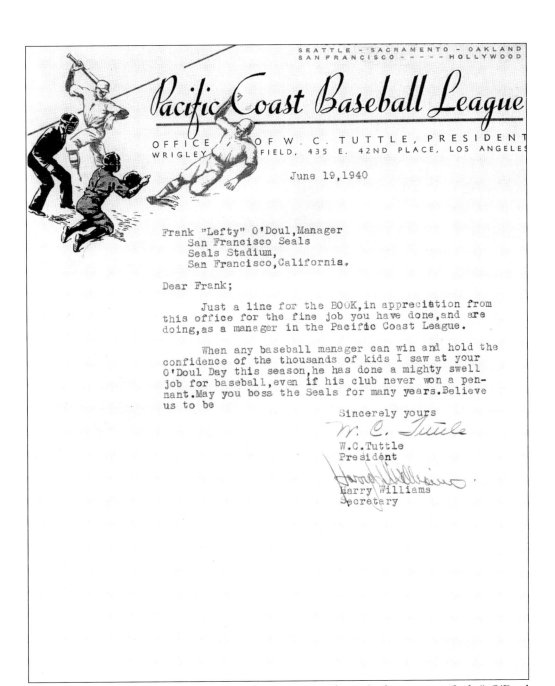

Pacific Coast Baseball League

OFFICE OF W. C. TUTTLE, PRESIDENT
WRIGLEY FIELD, 435 E. 42ND PLACE, LOS ANGELES

June 19, 1940

Frank "Lefty" O'Doul, Manager
San Francisco Seals
Seals Stadium,
San Francisco, California.

Dear Frank;

 Just a line for the BOOK, in appreciation from this office for the fine job you have done, and are doing, as a manager in the Pacific Coast League.

 When any baseball manager can win and hold the confidence of the thousands of kids I saw at your O'Doul Day this season, he has done a mighty swell job for baseball, even if his club never won a pennant. May you boss the Seals for many years. Believe us to be

 Sincerely yours

 W.C. Tuttle
 President

 Harry Williams
 Secretary

Pictured here is a letter from Seals president W.C. Tuttle to Seals manager "Lefty" O'Doul commending his fine performance for the exceptional job with the team during the 1940s.

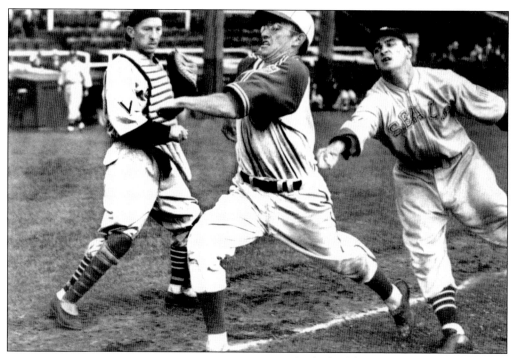

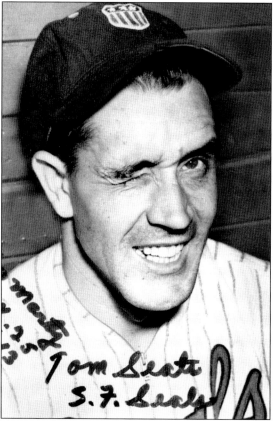

Seals third baseman Don White applies the tag on Oakland's Bill Rigney in a rundown as catcher Joe Sprinz avoids the interference call. This game was played at Emeryville in 1942.

Hurler Tom Seats had great endurance and usually went the distance. He was masterful with his change-up and sinker. He is best known for tossing two shutouts (6-0, 3-0) on the same day of a twin bill against Sacramento on August 6, 1943. During his four years with the Seals (1941–1944), he had a combined 63-60 record, 407 strikeouts, and 17 shutouts.

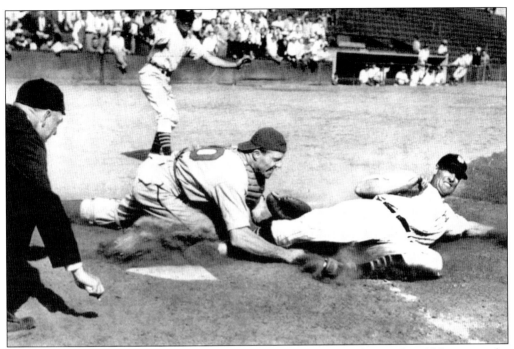

First baseman Gus Suhr is tagged out in the ninth inning by Seattle's catcher Al Sueme in the 1943 home opener at Seals Stadium. The Seals won the 6-5 thriller.

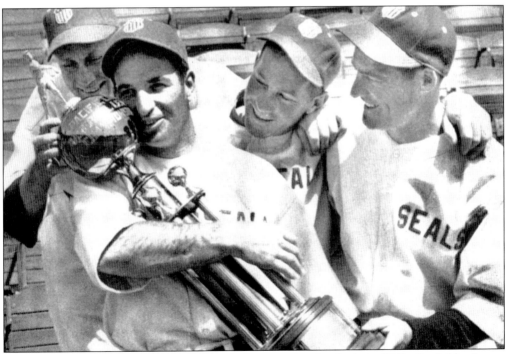

Pitcher Bob Joyce embraces the Governor's Cup won by the Seals in 1943. Outfielder Logan Hooper (left), clubhouse attendant Johnny Logan (center), and first baseman Gus Suhr (right) also enjoy the moment.

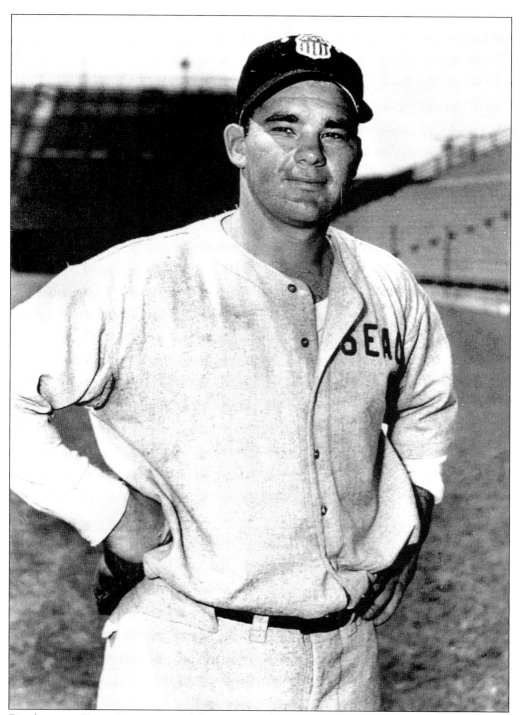

First baseman Ferris Fain was one of the most popular Seals ever. He was brash and hot tempered, and though he did everything everybody else did—he just did it better. He was a superb hitter and an excellent fielder. In 1946, he drove in 112 runs with his bat and probably saved 100 with his glove. Fain played five years with the Seals (1939–1942, 1946) before advancing to the major leagues for the next nine years.

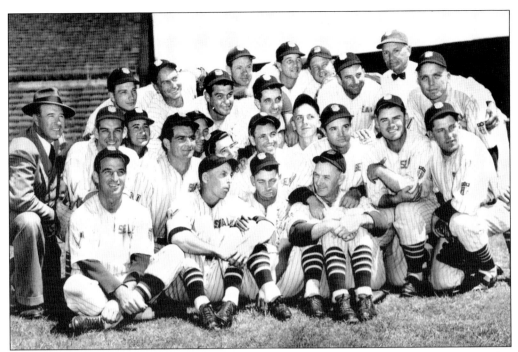

The 1943 Seals, managed by "Lefty" O'Doul, finished in second place with an 89-66 record and won their first of four straight Governor's Cups. The opening-day lineup was Frenchy Uhalt (OF), Hank Steinbacher (OF), Del Young (2B), Gus Suhr (3B), Charles Peterson (OF), George Metkovich (1B), Don Trower (SS), Joe Sprinz (C), and Bob Joyce (P).

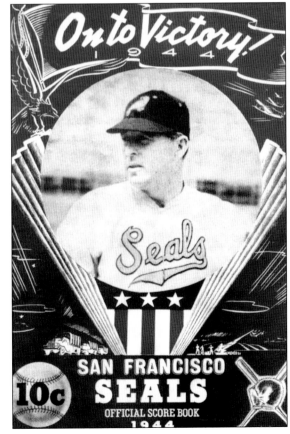

Manager "Lefty" O'Doul is pictured on the cover of a 1944 Seals scorecard. Covers with patriotic themes during the war were dedicated to all Seals players serving in the armed forces.

Pitcher Larry Jansen signed with the Seals in 1941. He was a fan favorite because of his competitiveness and usually finished each game he started. Jansen's fastball was not incredibly fast, but he had an excellent assortment of pitches—a curveball, sinker, and a mastered slider. He pitched two seasons for the Seals (1941–1942) and returned for seven games (4-1, 55 innings pitched) at the end of 1945. He won 30 games in 1946. From 1943–1945, Jansen worked on his farm to receive military deferment.

Bob Joyce was an early proponent of the slider. He won 20 or more games four different times as a Seal. He was always in command of his fastball and compiled 439 career strikeouts in 1,625 innings. Joyce pitched seven seasons for the Seals from 1941 to 1945 and again in 1947 and 1948.

Speedy Frenchy Uhalt led the team in stolen bases three of the four years he played with the Seals (1943–1947). He roamed the outfield and was an adequate hitter who had more triples than home runs. Uhalt didn't have the greatest arm, which limited his major-league career to 57 games with the Chicago White Sox in 1934.

Joe Sprinz was an excellent catcher who was with the Seals for 10 years (1928, 1938–1946). He played in 976 games with a combined .250 batting average. He is best known for a stunt negotiated by Walter Mails at the 1939 World's Fair at Treasure Island. Called "The Great Balloon Drop," Sprinz attempted to catch a ball dropped from a blimp some 1,000 feet above a baseball diamond. Unfortunately, the ball traveling at an estimated 150 miles an hour glanced off his mitt breaking 12 bones in his face and knocking out 5 teeth. The tragedy caused Sprinz to miss the last 42 games of the season.

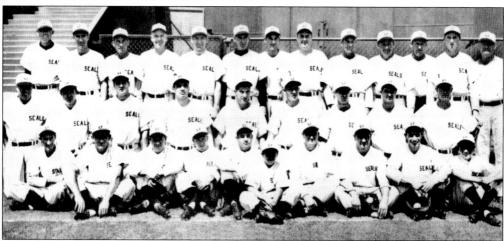

The 1946 PCL champion Seals, managed by "Lefty" O'Doul, finished in first place with a 115-68 record and won their fourth straight Governor's Cup. Pictured, from left to right, are: (bottom row) Ed Stutz (P), Neil Sheriden (OF), Bruce Ogrodowski (C), Don Trower (IF), Ferris Fain (1B), Morris (batboy), Hugh Luby (2B), Frank Rosso (P), Dom DiMaggio (OF), and Matsen (ballboy); (middle row) manager "Lefty" O'Doul, "Frenchy" Uhalt (OF), Don White (OF), Sal Taormina (OF), Ted Jennings (3B), Roy Nicely (SS), Joe Hoover (SS), Mel Ivy (C), and Coach Young; and (top row) Bill Melton (P), Dino Restelli (OF), Joe Spinz (C), Al Lien (P), Bill Werle (P), "Bones" Sanders (1B), Larry Jansen (P), Frank Seward (P), Ray Harrell (P), Doug Loane (P), Jim Tobin (P), Emmitt O'Neil (P), and Leo Hughes (trainer).

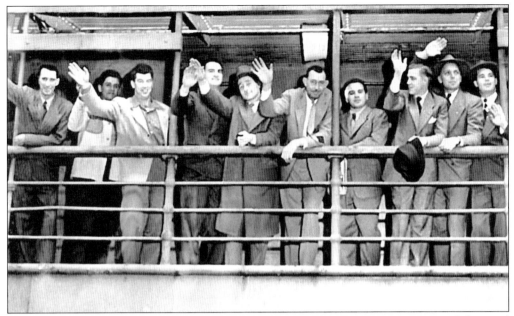

Seals players wave aloha to their fans on the way to spring training in Hawaii in 1946. Pictured here, from left to right, are Eddie Stutz (P), Neil Sheridan (OF), Ted Jennings (3B), Don White (OF), Frank Rosso (P), Cliff Melton (P), Ray Perry (OF), Roy Nicely (SS), Al Lien (P), and Ferris Fain (1B).

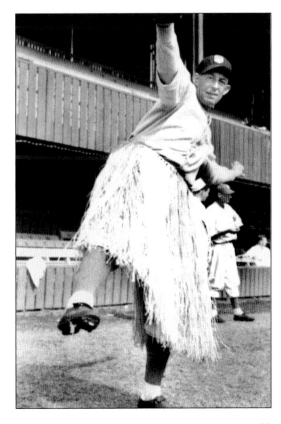

During spring training Cliff Melton tries out his "Aloha" windup at owner Paul Fagan's ranch in Hawaii in 1946. Melton had excellent control with a fine sinker ball. He pitched five years for the Seals from 1946 to 1950, with a combined 66-57 record and 497 strikeouts.

Pitcher Bill Werle, nicknamed "Bugs," was a side-winding lefty who broke in with the Seals in 1943. He was basically a sinker-ball pitcher with superb control. He also possessed an excellent fastball. In his five years with the Seals (1943–1944, 1946–1948), he compiled a 56-48 record with 426 strikeouts before being sold to the Pirates in 1949.

Southpaw Al Lien was a control artist with a good change of pace. He was also a dominant pitcher with a good assortment of pitches. Lien was known to like the cool weather at Seals Stadium, except when the fog rolled in. During his 11 seasons with the Seals (1942–1943, 1946–1954), he accumulated a 126-118 record with 752 strikeouts.

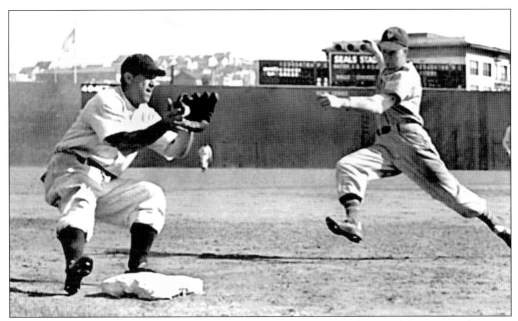

Third baseman Ted Jennings prepares to put the tag on Whitey Lockman of the New York Giants at Seals Stadium during a 1946 exhibition game. Jennings was a mainstay with the Seals, playing for nine years from 1936 to 1942 and again in 1946–1947. Due to irreconcilable differences, "Lefty" O'Doul benched him mid-season in 1947, and he was released on October 1.

Roy Nicely was an outstanding shortstop in the post-war era and also had a great arm with marvelous range. His forte was throwing from the hip—without looking—and turning a double play. Nicely teamed with second baseman Del Young in 1945 to form an acrobatic combo, they turned 179 double plays—a team record. He played six years with the Seals, from 1945 to 1950.

Joe Brovia, nicknamed "Pino," was a terrific left-handed outfielder. He was the type of player who could beat you several different ways. He attacked the baseball with ferocity and was a solid .300 hitter. As quick as he was with his bat, his temper was even quicker, and it usually got him in trouble. He was famous for wearing his pants to his ankles—a source of constant consternation to Seals owner Paul Fagan. Brovia played 1941, 1942, and 1946–1948 for the Seals.

Bob Chesnes, called "Bullet Bob," signed as a switch-hitting shortstop in 1940. In 1942, though, O'Doul told Chesnes that "he couldn't hit a bull in the fanny with a bass fiddle," and convinced him his future would be as a pitcher. Chesnes became one of the greatest pitching prospects ever developed in the PCL. He had a blazing fastball and great command of his pitches—always moving the ball around. The military interrupted his prosperous career in 1943 and Chesnes pitched only two seasons, 1942 and 1947, for the Seals.

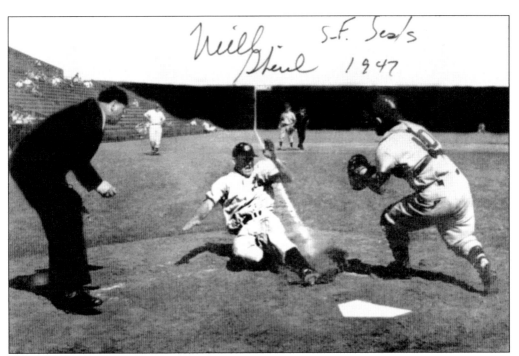

Outfielder Neil Sheridan, nicknamed "Big Buffalo," slides home with the lead run in the Seals 5-3 win over Hollywood in 1947. Sheridan was a self-described line-drive hitter, yet was high among the home-run leaders and run producers. He played six full years with the Seals (1943–1947, 1950, as well as parts of the 1951 and 1954 seasons).

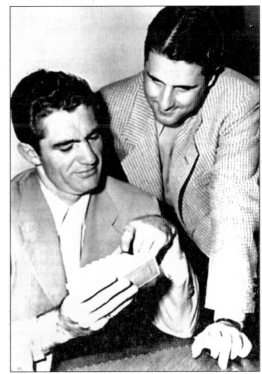

Outfielder Dino Restelli (left), shows off his playing hand to third baseman Ray Orteig in 1947. Restelli, a keen-eyed Italian, was blessed with excellent speed and power. He was known for his punishing bat—hitting in the .310 range. He played six seasons with the Seals (1944, 1946–1950) with a combined 282 runs scored, 283 RBI, and 48 home runs.

93

Hugh Luby came to the Seals from the Giants as part of a trade in 1946. He was a steady, dependable second baseman and played in more consecutive games—866—than anyone else in PCL history. He had a bullet arm with great flexibility and balance. His tenure lasted three years with the Seals (1946–1948).

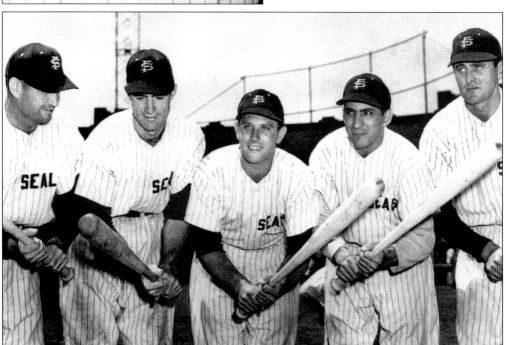

The 1948 Seals pictured, from left to right, are Hugh Luby (2B), Dino Restelli (LF), Gene Woodling (CF), Mickey Rocco (1B), and Joe Brovia (RF).

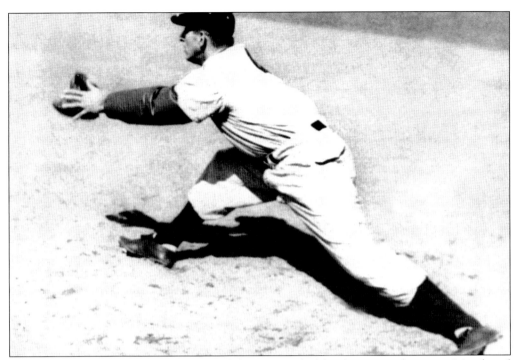

First baseman Mickey Rocco was one of the most valuable players on the team. Monikered "Socco" for his power and defensive skills, he had a barrage of extra-base hits with the Seals—36 doubles, 149 RBI, and 27 home runs—leading the team in 1948. He played for the Seals in 1948 and 1949 after a mediocre four-year career (1943–1946) with Cleveland.

Outfielder Gene Woodling played only one season with the Seals in 1948. Manager "Lefty" O'Doul devised a new batting stance for him that resurrected the career of the rising star. Not only did Woodling win the batting title (.385 batting average), he was promoted to the major leagues and had an outstanding career with the Yankees. He played in five World Series.

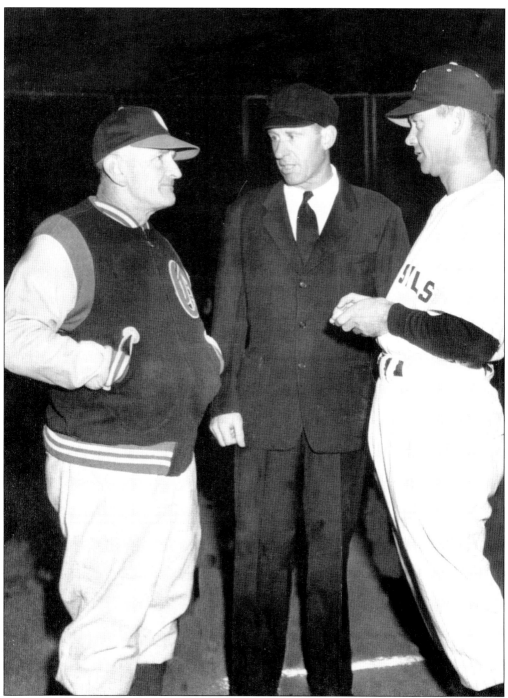

Skipper Casey Stengel of the Oakland Oaks (left) and Seals coach Del Young exchange lineup cards with the umpire before a game in 1948.

Shortstop Floyd "Arky" Vaughn joined the Seals in 1949. During his 14-year career in the National League he was an outstanding player as well as a seven-time all-star. In his only season with the Seals, he brought experience and leadership while batting .288. He retired on September 1, 1949, due to a severe bladder condition. Sadly, while fishing about 20 feet from shore he drowned on August 30, 1952. He was 40 years old.

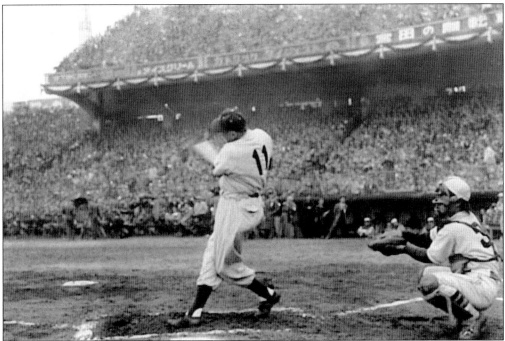

Manager "Lefty" O'Doul's appearance at the plate was merely a treat for the Japanese at Korakuen Stadium in 1949. Over 55,000 clamored to see the former big-league star take a swing. O'Doul brought a contingent of Seals players for the two-week trek across the Pacific, playing exhibition games against Japanese all-stars in Tokyo, Osaka, and Kyoto, and with stops in Honolulu, Manila, and Wake Island against military teams. The Seals went 9-0 against the Japanese and 3-1 against the service teams.

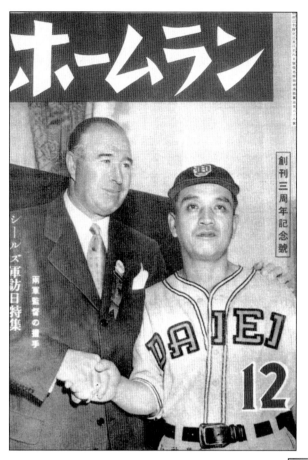

"Lefty" O'Doul adorns the cover of Japan's *Baseball Monthly* magazine, with the manager of the Daiei team in 1949. "Lefty" O'Doul was a man beloved by all Japanese fans. He first went to Japan in 1931 with a major-league all-star team that included Hall of Famers Frankie Frisch, George Kelly, Al Simmons, and Rabbit Maranvile. In 1932, O'Doul returned to Japan to teach and coach players at six universities and became known as the "Father of Japanese Baseball." In 1934, Babe Ruth joined O'Doul in Japan along with future Hall of Famers Lou Gehrig, Earl Averill, "Lefty" Gomez, Jimmy Fox, Connie Mack, and Charley Gehringer. O'Doul planned on taking a team to Japan in 1937, but the trip was cancelled and instead the Japanese sent a team to America to play teams on the West Coast. Later, World War II interrupted relations. O'Doul traveled on his own to Japan after the war and started the groundwork for resumption of relations between American and Japanese ballplayers. His first post-war tour team was in 1949.

The popular Con Dempsey is featured on the cover of the October *Yakyoki Sport* magazine during the Seals Goodwill tour of 1949. It was a triumphant return for Dempsey, who took part in the invasion of Okinawa during World War II as a member of the armed forces. He was an integral member of the Seals pitching staff for four years (1948–1951). Demsey was not overpowering, but had excellent control. He was among the PCL's best hurlers.

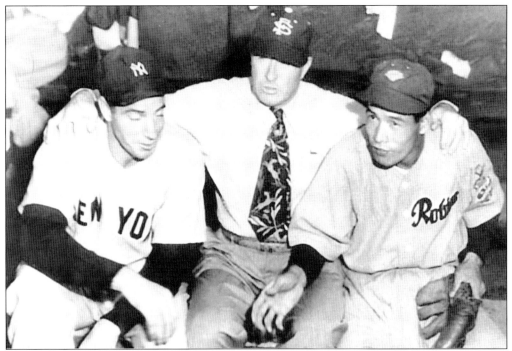

Yankee's Joe DiMaggio (left) and Seals manager "Lefty" O'Doul (center) reminisce with Kozura's home-run king of Japan prior to an exhibition against the major league all-stars that included the three DiMaggio brothers.

Outfielder Jackie Tobin takes part in a sliding drill during spring training under the observation of manager "Lefty" O'Doul. The speedy Tobin led the Seals in stolen bases during the 1949 and 1950 seasons.

It was a day for kids in Oakland when "Christmas in August" was staged for the benefit of underprivileged children in the Bay Area. Here Santa Claus is surrounded by Oakland manager Charlie Dressen (left), Seals skipper "Lefty" O'Doul (right), and three umpires working the game in 1949.

Catcher Ray Orteig, a 5-foot, 11-inch hustler of Irish decent, was a steady hitter who transformed from an all-around third baseman to an excellent catcher. With a great arm and quick release, base runners feared him. He played five years with the Seals in 1947, 1948, and 1950–1952, totaling 647 games with a combined .286 batting average and 38 home runs.

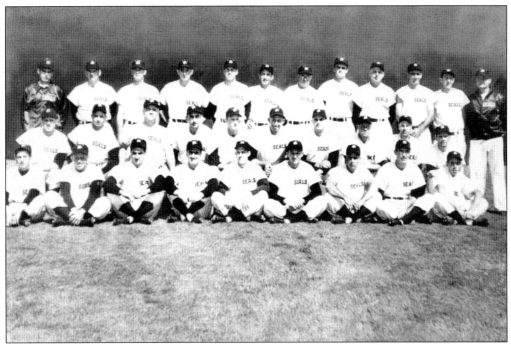

The 1950 Seals, managed by Lefty O'Doul, finished in fifth place with a 100-100 record. The opening-day lineup was Jackie Tobin (CF), Les Fleming (1B), Joe Grace (LF), Brooks Holder (RF), Dario Lodigiani (3B), Jimmy Moran (2B), Roy Nicely (SS), Ray Orteig (C), and Al Lien (P).

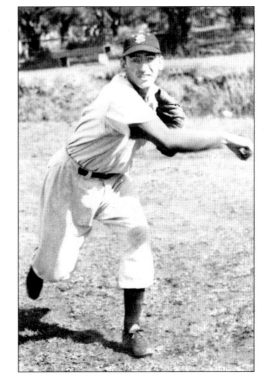

Manny Perez, a stalwart right-handed pitcher, was highly coveted by the Seals. He threw two no-hit games with the East Texas League before signing with the Seals in 1948. Perez pitched four years for the Seals (1948–1951), compiling a 34-29 record and a 3.75 ERA.

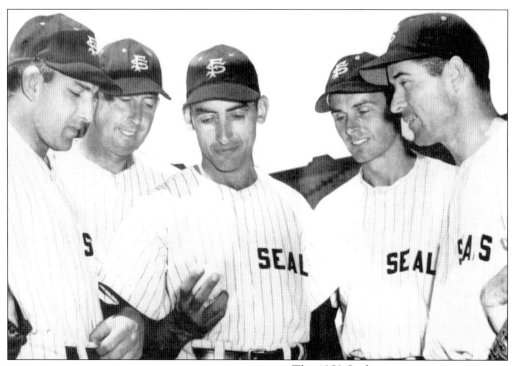

The 1950 Seals starting rotation, from left to right, are Bill Werle, Cliff Melton, Manny Perez, Jack Brewer, and Chet Johnson. Johnson won only 5 of 20 decisions at mid-season and was sent to Oakland.

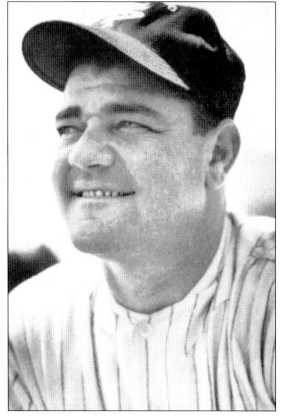

Les Fleming was an adequate first baseman and he could hit the long ball. Because of his stature, he was nicknamed the "Fireplug." He replaced Mickey Rocco at first base and added offensive punch to the lineup. Fleming played in 1950 only, as owner Paul Fagan banned him from the team because he felt he was bullish. Fagan's decisions did not always make good baseball sense.

SEVEN

THE END OF AN ERA

In 1951, the Seals arranged a working agreement with the Yankees to send players to the majors. With the exception of Lew Burdette (14-12) and shortstop Jim Bridewiser (.283), it turned out to be a disaster. Pitching "prep phenom" Ed Cereghino, 17, from the city's sandlots was signed. O'Doul used 17 players in the opener against San Diego, but by mid-season 13 were gone and by the end of the season only 9 were left on the roster. The Seals spent most of the season mired in the cellar and finished in eighth place with a disappointing 74-93 record—25 games behind Seattle. The last day of the season was "Lefty" O'Doul Day at Seals Stadium; however, the Seals first cellar finish since 1926 overshadowed it.

O'Doul was fired in 1952 and new manager Tommy Heath was hired. Still, the team played poorly. They finished near the bottom in seventh place with a 78-102 record and 31 games behind Hollywood. Aging first baseman Joe Grace (.299) and third baseman Reno Cheso (.278) contributed 281 hits collectively, and pitchers Elmer Singleton (17-15) and Bill Bradford (15-11) anchored the staff.

The 1953 Seals rebounded with a winning season. They finished at 91-89, good enough for fifth place—15 games back of Hollywood. Tommy Heath gathered together a spirited group, but owner Paul Fagan put the Seals up for sale and threatened to close the ballpark. Ultimately, the league bought the Seals from Paul Fagan for $100,000. Outfielder Sal Taormina (.297) and third baseman Reno Cheso (.297) shared the team batting title.

The team had a new look in 1954 with the acquisition of outfielders Bob DiPietro (.269) and Gordy Brunswick (.242). Dubbed by the media as the "Kiddie Car Express" because of the team's youthful players, the Seals generated fan interest and attendance went up. They finished in fourth place at 84-84, and were 17$\frac{1}{2}$ games behind San Diego. The Seals qualified for the Governor's Cup playoffs and survived the first round, winning two of three from Hollywood, only to be swept by Oakland in three straight games the next round.

Languishing in the depths near the bottom of the division for most of the 1955 season, the Seals climbed to sixth place to finish at 80-92. Of the regular eight position players from the 1954 team, only two retained their jobs—second baseman Jim Moran and outfielder Ted Beard. Still, the Seals with their new lineups led the league in batting (.268). Shortstop Mike Baxes (.323) and outfielder Dave Melton (.299) were the team leaders. Unfortunately though, attendance was dwindling and the league sold the team to the Boston Red Sox for the 1956 season.

The Red Sox stocked the Seals roster with top-notch talent for the 1956 season with center fielder Albie Pearson (.297), second baseman Ken Aspromonte (.281), third baseman Frank Malzone (.296), right fielder Tommy Umphlett (.285), catcher Hayward Sullivan (.296), and outfielder Marty Keough (315). Tommy Heath was replaced by Eddie Joost to manage the club, but the Seals faltered again and by mid-season Joost was fired. He was replaced by the popular Joe Gordon, who directed the Seals to a sixth-place finish with a 77-88 record—28½ games behind Los Angeles. Hard-throwing Jerry Casale (19-11, 4.10 ERA), the bigwig of a weak pitching staff, is credited with hitting the longest home run (560 feet) at Seals Stadium.

In a fitting conclusion to the San Francisco Seals longevity, the Seals rebounded in their final season ever to win the 1957 pennant with a 101-67 record and 3½ games ahead of Vancouver. The foremost additions to the team were first baseman Frank Kellert (.308), outfielders Bill Renna (.281), Marty Keough (.285), and second baseman Ken Aspromonte (.334), who ended up leading the PCL. Right fielder Albie Pearson (.297) led the team in runs scored with 99, and pitchers Leo Kiely (21-6) and Bill Abernathie (13-2) were part of the Seals dominant bullpen. They ended up leading the PCL in batting (.278), and attendance for their final season was 284,532.

With the arrival of the major-league Giants from New York in 1958, 55 years of minor league baseball had concluded in San Francisco. It was the end of a fascinating journey for the Seals, lasting five decades and for most of the 20th century.

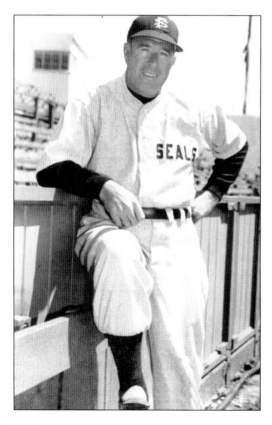

The legendary "Lefty" O'Doul was fired by owner Paul Fagan after the 1951 season. O'Doul guided the Seals to two pennants during his 17 years (1935–1951) as skipper, winning pennants in 1935 and 1946.

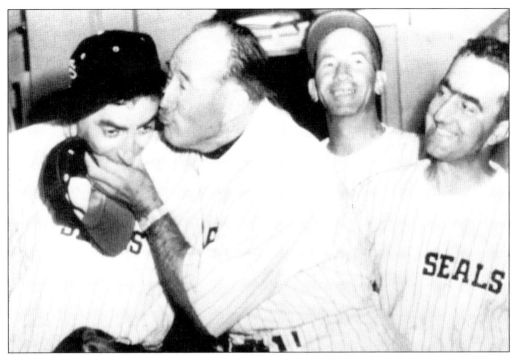

Manager "Lefty O'Doul" has a reason to celebrate. Here he kisses pitcher Manny Perez for snapping a 13-game losing streak in 1951. Catcher Joe Sprinz (back) and third baseman Dario Lodigiani (right) are enthusiastic.

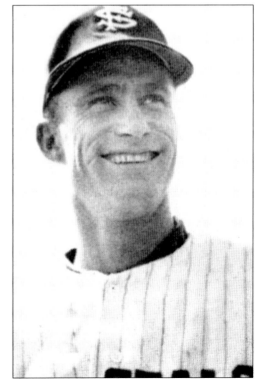

Pitcher Lew Burdette won more than 250 games during his 21-year career in professional baseball, though only 14 of those wins came with the Seals in 1951 before he was recalled by the Yankees on August 30, 1951. Uncharacteristically, the Seals finished in last place, though Burdette's 14-12 record and his 3.21 ERA led the team.

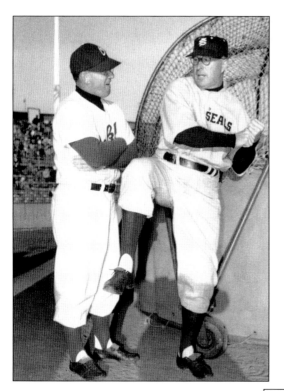

Seals manager "Lefty" O'Doul (right) impersonates Oakland skipper Mel Ott with his unique batting stance—lifting his front leg before swinging. The result was a level swing with terrific power that Ott possessed during the 1920s and 1930s.

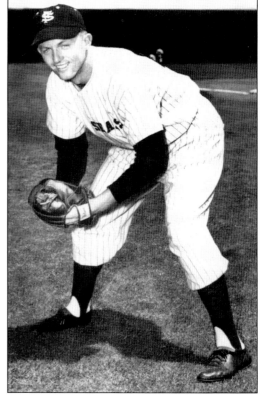

Jimmy Moran was a slick second baseman who teamed with shortstop Leo Righetti for outstanding double-play combinations. He had a great arm and was always a hustler. Moran could kick a ball and still make the play. His .982 fielding percentage led the PCL in 1954. He compiled a .273 batting average during his seven years with the Seals (1949–1955).

Young Reno Cheso was a star athlete picked right off the sandlots of San Francisco. He played second base in 1949 and 1950, then moved to third base and was a regular there from 1952to 1955. Cheso never developed as expected though. He was slow afoot and the Seals could not find a position for him to play adequately. He finished his career as a catcher. Cheso played seven years, compiling a .263 batting average, 247 runs scored, 262 RBI, and 28 home runs.

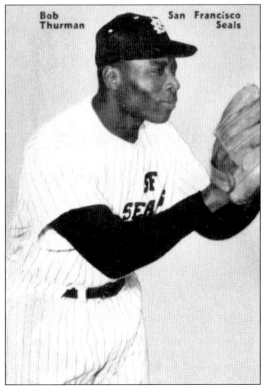

The Seals broke the color barrier by signing outfielder Robert Thurman in 1951. He had excellent power from the left-handed side of the plate. Thurman could hit the ball out of any ballpark. The records show he was not the first known African American to play in a Seals game though. On opening day, March 31, 1951, he was out with a sprained ankle and Frank Barnes pitched one inning. Thurman made his debut on April 3, 1951, and appeared in 116 games, batting .280 and hitting 13 home runs in his only season with the Seals before moving up to the major leagues.

The veteran Elmer Singleton pitched for seven teams in 21 seasons of pro ball. During that period, he pitched six seasons for the Seals (1949–1954). He was an intelligent pitcher and called his own games. Singleton had a combined 63-72 record with a 3.14 ERA.

Bill McCawley was a good center fielder who teamed with the speedy Jack Tobin in the outfield. He wasn't as flamboyant as Tobin, but he was a long-ball pull hitter. McCawley played five years with the Seals (1950–1954), compiling a .272 batting average with 25 home runs.

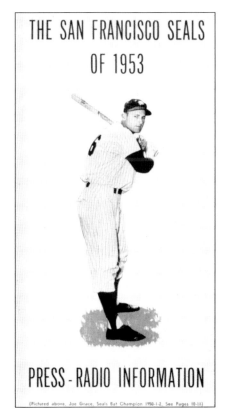

THE SAN FRANCISCO SEALS OF 1953

PRESS-RADIO INFORMATION

(Pictured above, Joe Grace, Seals Bat Champion 1950-1-2, See Pages 10-11)

Pictured on the official press-radio information guide is Joe Grace, who was acquired from Sacramento in 1950 and took over at first base. Even at an advanced age Grace was able to hit .335 in 1950 and .302 in 1951 to lead the Seals in batting average two of the fours years he played for them (1950–1953).

Pictured here is Owner Paul Fagan (left) and General Manager Joe Orengo (right) with a couple of young Seals fans. Fagan treated his players well and they enjoyed first-class hotels on road trips, ate at the best restaurants, and traveled regularly on airplanes to as far away as Japan. Fagan tried to build the Pacific Coast League into a third major league, but everything changed when he fired "Lefty" O'Doul.

A 1954 San Francisco Seals preferred stock certificate shows ownership shares in the Seals. It is signed by Damon Miller, president of the Seals.

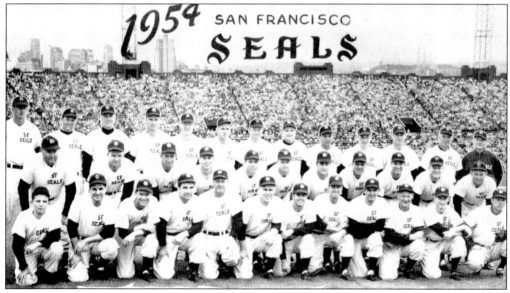

The 1954 Seals, managed by Tommy Heath, finished in fourth place with an 84-84 record. The opening-day lineup was Mike Baxes (LF), Jimmy Moran (2B), Jim Westlake (1B), Leo Righetti (3B), Reno Cheso (SS), Sal Taormina (RF), Bob DiPietro (CF), Nini Tornay (C), and Tony Ponce (P).

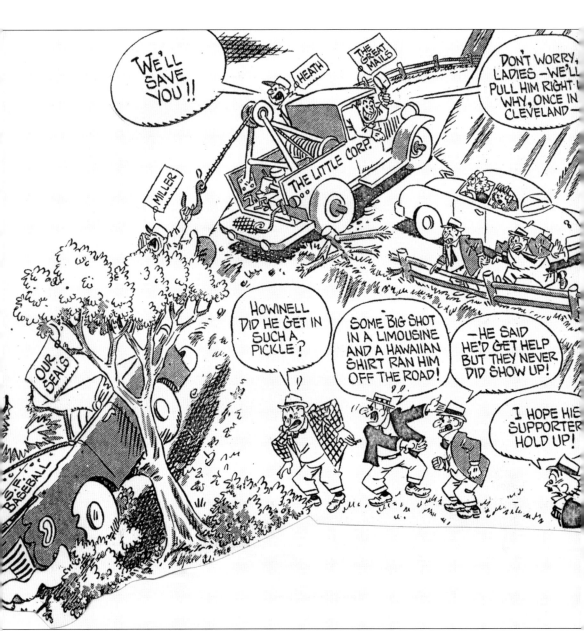

With the team close to bankruptcy in 1953, the league appointed Damon Miller, Paul Fagan's secretary and general manager, as president and conservator of the Seals. Miller formed the "Little Corporation" to raise money to operate the team in 1954, but after the 1955 season the corporation went broke. Ultimately, the Boston Red Sox bought the Seals, assuring there would be Seals baseball in 1956.

Ted Beard played for the Hollywood Stars during their "dynasty years" (1951–1953) and helped them win two pennants. He was sold to the Seals in 1954 and immediately established stability in the Seals outfield along with Sal Taormina and Bob DiPietro. No one expected much power from Beard, but he led the team in stolen bases in 1955. Beard played two years with the Seals (1954–1955).

Tony Ponce broke in with the Seals in 1953 as a 31-year-old rookie with great stamina and experience. Although Ponce had a mediocre fastball, a so-so slider, a decent forkball, and only threw in the low 80s, no Seals pitcher had a more auspicious debut. In his rookie year, he went 8-0 with a low 1.31 ERA—the lowest on the team. He pitched three years for the Seals (1953–1955) with a combined 32-28 record and a 3.41 ERA. Ponce also had a killer knuckleball.

Manager Tommy Heath was admired by all of his players. He gave them a lot of latitude and had a short leash. Normally Heath was low key, but he had a quick tongue and could bark with the best. He managed the Seals for four years from 1952 to 1955, compiling a 333-367 record.

After winning 20 games as a rookie for the Cleveland Indians in 1948, hurler Gene Bearden played with the Seals in 1955. He was an experienced pitcher and knew how to throw strikes. His 17 completed games was tops on the pitching staff.

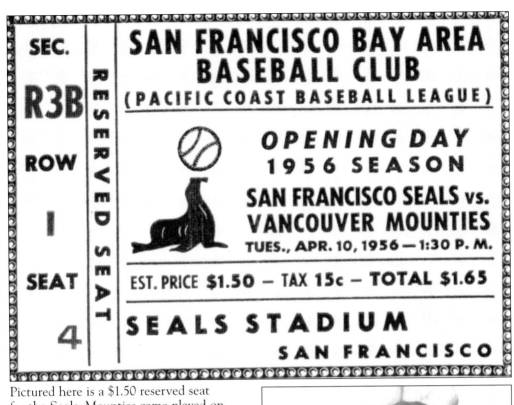

SEC. **R3B**	R E S E R V E D S E A T	**SAN FRANCISCO BAY AREA** **BASEBALL CLUB** (PACIFIC COAST BASEBALL LEAGUE)

<table>
<tr>
<td>SEC.

R3B

ROW

1

SEAT

4</td>
<td>R E S E R V E D S E A T</td>
<td>**SAN FRANCISCO BAY AREA**
BASEBALL CLUB
(PACIFIC COAST BASEBALL LEAGUE)

OPENING DAY
1956 SEASON
SAN FRANCISCO SEALS vs.
VANCOUVER MOUNTIES
TUES., APR. 10, 1956 — 1:30 P. M.

EST. PRICE $1.50 — TAX 15c — TOTAL $1.65

SEALS STADIUM
SAN FRANCISCO</td>
</tr>
</table>

Pictured here is a $1.50 reserved seat for the Seals–Mounties game played on opening day, Tuesday, April 10, 1956, at Seals Stadium.

After three years in the major leagues with the Red Sox and Senators, center fielder Tommy Umphlett signed with the Seals in 1956. He was a defensive gem and was considered by many as the best defensive center fielder to wear the "SF" monogram since Joe DiMaggio. Umphlett suffered leg injuries in 1956 and his loss contributed greatly to the Seals falling out of contention. He played two seasons with the team (1956–1957), with a combined .264 batting average, 87 runs scored, 96 RBI, and 9 home runs.

Pictured here is a five-inch souvenir decal that was inscribed "I'm a Booster." The decal could be attached to an automobile window.

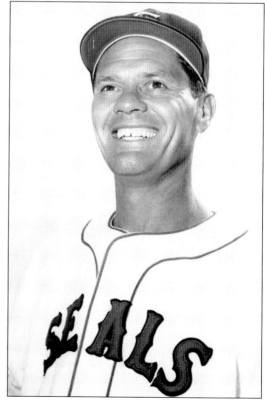

Eddie Joost was a fluid shortstop in his prime, but played only sparingly for the Seals, the team he managed in 1956. With high expectations and the influx of talented young players, the Seals encountered a nine-game losing streak while struggling in sixth place. Joost was fired and replaced by Joe Gordon, who finished the season.

Seals Stadium glistened on opening day, April 11, 1957, against Portland. Harry Dorish shutout the Beavers 3-0 before a sparse crowd of 6,412.

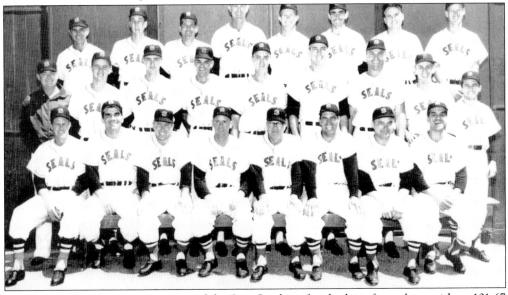

The 1957 PCL champions, managed by Joe Gordon, finished in first place with a 101-67 record. Pictured, from left to right, are: (bottom row) Tom Hurd (P), Sal Taormina (OF), Bill Abernathie (P), Joe Gordon, manager, Glenn Wright, coach, Nini Tornay (C), Harry Dorish (P), Ken Aspromonte (2B); (middle row) Leo Hughes, trainer, Bill Prout (P), Jack Spring (P), Leo Keily (P), Frank Kellert (1B), Haywood Sullivan (C), Bill Renna (OF), Ed Sadowski (C), Albie Pearson (OF); and (top row) Grady Hatton (3B), R.W. Smith (P), Bert Theil (P), Jack Phillips (LF), Marty Keough (OF), Tom Umphlett (OF), Robert Chakales (P), and Harry Malmberg (SS).

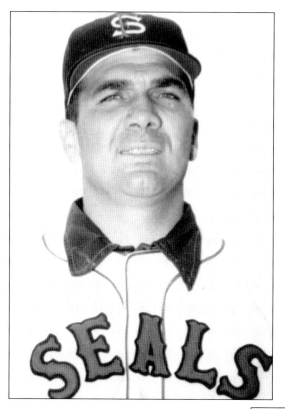

Sal Taormina, called "Hoggie," had been up and down with the Seals since he signed with them in 1942. He was an all-purpose infielder and outfielder, but most of all a consistent hitter. Taormina played with the Seals eight years (1942, 1946, 1948, 1952–1957), compiling a .277 batting average, 351 runs scored, 355 RBI, and 48 home runs.

Haywood Sullivan, an excellent catcher, was one of the Seals top prospects in 1956. He shared the catching position with Eddie Sadowski in 1957. Sullivan was productive with his bat and played two seasons for the Seals (1956–1957), batting a combined .295 batting average, with 88 runs scored, 110 RBI, and 17 home runs.

The Seals infield was strengthened in 1956 with the arrival of flamboyant Ken "Chip" Aspromonte. He played hard and was a great roving second baseman who made plays. Aspromonte had decent power and was a dangerous long-ball hitter. He played two seasons with the Seals (1956–1957), and won the batting title in 1957 with a .334 batting average.

Pictured, from left to right, are Frank Kellert (1B), Grady Hatton (3B), Pumpsie Green (SS), and Harry Malmberg (2B)—all infielders for the 1957 Seals.

Bob DiPietro was a hustler and clubhouse comic. He was also spontaneous on the field and had a strong arm. He suffered a broken ankle during the 1955 season, but led the Seals with a .371 batting average. His claim to fame was a stint with Boston of the American League. While playing right field in Yankee Stadium, he threw out the fleet-of-foot Mickey Mantle at home plate, earning him the nickname "The Rigitoni Rifle."

Catcher Nini Tornay was considered a true Seal with a spring-steel throwing arm. He signed with them in 1949 and remained there until 1957. Though Tornay was a good catcher, he was a weak hitter and never got a shot with a major-league team. In his nine years with the Seals, he compiled a .235 batting average, with 97 runs scored, 125 RBI, and 5 home runs.

Third baseman Frank Malzone was a sound ballplayer with an excellent arm. He played in only 87 games in 1956 before being elevated to the Red Sox—the beginning of a brilliant career in the majors.

Outfielder Sal Taormina, the tobacco-chewing milkman from San Jose, poses with utility outfielder Hal Grote in this 1957 photo.

Leo Hughes was the Seals trainer and equipment manger for more than a decade. Hughes, a San Francisco native, learned much of his baseball knowledge from Shine Scott and Red Adams, former trainers of the Mission Reds, along with Seals trainers Denny Carroll and Bobby Johnson. When Seals trainer Bobby Johnson died in 1946, Hughes was named head trainer. He stayed with the team until 1957.

Outfielder Marty Keough, another of the Red Sox prime rookies, came to the Seals early in 1956. Like many others, he developed into a good ballplayer and became a drum-fire singles hitter and brilliant outfielder. During his two years with the Seals (1956–1957) he had a .296 batting average, with 154 runs scored, 91 RBI, and 22 home runs.

Outfielder Bill Renna supplied the power the Seals needed during their pennant drive in 1957. The Seals shelled out $40,000, plus promising outfielder Gordie Windhorn and pitcher Eli Grba, to acquire Renna's thundering bat and strong arm. His 29 home runs led the team in 1957. Renna was the only known Seal to hit a baseball against the clock on the left-center field light tower—a 550-foot home run.

A general admission ticket booklet held five tickets. For $5, Seals fans became bleacher bigwigs in left or right field during the 1957 season.

The talented and popular second baseman Elijah "Pumpsie" Green appeared in only nine games for the Seals in 1957, batting .333. Unexpectedly, he was ordered to report to the National Guard and missed the remainder of the season. In 1959, he moved up to the majors and became the first African American to play for the Red Sox.

Joe Gordon became the 18th manager in Seals history and succeeded Eddie Joost in July of 1956. He captured the imagination of the fans with his impish personality. Gordon was considered a player's manager and loved talking baseball. He had his own rules and guided the Seals to their last PCL pennant in 1957.

Albie Pearson was a diminutive 5-foot-5-inch, 140-pound right fielder with a big heart. He was an outstanding bunter and could hit the curveball and fastball. He seldom swung at bad pitches. Pearson played two seasons with the Seals (1956 and 1957), with a combined .297 batting average. The following year he advanced to the majors and won the American League Rookie of the Year award with the Washington Senators.

Robert "Riverboat" Smith was a dominant southpaw pitcher. The media compared R.W. Smith's demeanor to that of a Mississippi riverboat gambler, so "Riverboat" stuck with him. He had pin-point control and a deliberate style of pitching. Smith signed with the Seals in 1956 and led the pitching staff in 1957 with a 13-10 record, 120 strikeouts, and 6 shutouts—tops in the PCL.

Southpaw Leo Kiely was the only reliever to ever win 20 games as a Seal. After beginning the 1957 season as a starter with an uninspiring 1-2 record, he moved to the bullpen and ended up with an overall 21-6 record. His low 2.22 ERA got him all-star recognition. Kiely pitched for two seasons, 1956 and 1957, with the Seals.

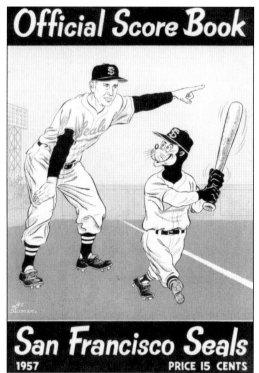

Here is the official scorecard from the last game played at Seals Stadium on September 13, 1957—a doubleheader loss to Sacramento. Six decades of Seals baseball might be over in San Francisco, but on Bryant Street across from where the stadium was demolished in 1959, a shrine at the Double-Play Restaurant and Bar pays tribute to the memory of the Seals, featuring photos, murals, ball caps, mitts, jerseys, gloves, and even the top of the Seals Stadium flagpole.

Author Martin Jacobs, then age 14, watched the last Seals game at Seals Stadium. Working as a concessionnaire during both games of the doubleheader, he witnessed mixed emotions in the stands that day. With the Seals moving to Phoenix the following year, San Francisco was getting ready to greet the Giants.